THE AKRON
SOUND

THE AKRON SOUND

SOUND

THE HEYDAY OF THE MIDWEST'S PUNK CAPITAL

CALVIN C. RYDBOM

THE
History
PRESS

Published by The History Press
Charleston, SC
www.historypress.net

Cover images, clockwise: Courtesy of the Bizarros, Jimi Imij, Chris Butler and Buzz Clic. Back cover courtesy of James Carney.

First published 2018

Manufactured in the United States

ISBN 9781625858634

Library of Congress Control Number: 2017960102

To my parents—even though when I was four they brought me home a little sister instead of the pony I really wanted. Truthfully, over the years, I have realized that it was a good choice on their part, as I've grown to appreciate her as well. Although a pony would have been nice.

CONTENTS

Contents

PREFACE

ately I've been asked an obvious question about why this book is going to exist by those outside our region and, oddly enough, by a lot within the Akron area. Why was I working on this book? Don't you write books about disasters? For that matter, why would anyone, not just me, want to read a book about Akron and its surrounding region's music history? My answer is incredibly simple. There is only one reason for anyone to write about music, whether it be an era, region, style or sound—because some great rock, pop, punk, R&B, jazz and rap have been created that had a connection to that place. It's also the exact same reason you should be reading it—or, at the least, seek out some of the music you'll read about in these pages. And while, truthfully, the phrase the "Akron Sound" specifically refers to the punk/new wave sound that exploded here in the late 1970s and early 1980s, this region and this book can't just be about those few years. So, while that amazingly fertile period is really the subject of this book, you can't really talk about those years without spending a little time on what came before those years. And you certainly can't ignore the performers who came after and how they were influenced by those years. It hasn't just been the Black Keys over the past thirty years.

It would be very easy to start our story with Ruby and the Romantics scoring a number one single with "Our Day Will Come" in 1963 and then following it up with two more Top 40s singles on the *Billboard* charts and five more Top 20 singles on the R&B charts. They were the first group to do music geared toward young people and inspire others to form a band. But

there was also some great music before them, specifically the jazz scene on Howard Street, although there isn't much linkage to the "Akron Sound" that came out of what was for decades the business district for Akron's ethnic and minority residents. It would be just as easy to act as if our story stops with chart-topping acts today such as the Black Keys and Red Sun Rising. But there are far too many young acts around town today to ever really end the story. So, while the book is about the "Akron Sound," it's also about the sounds that came before and after.

And it isn't really just Akron either. So much of what became known as the "Akron Sound" originated in Kent, just a few minutes down the road. It had a university full of students hungry for original music, as opposed to cover bands playing the current Top 40, just as Akron had and has. For whatever reason, though, a lot more of the musicians found themselves as students at Kent State rather than the University of Akron. Looking back to that time, Kent State had more of an aura of creativity around it. In fact, the show *Village Voice* critic Robert Christgau attended that resulted in him often getting credit for coining the phrase the "Akron Sound" was at JB's in Kent. Fun fact, though: he did not use the phrase "Akron Sound" in his article, nor in any reviews he did of the bands. And he argued that the Akron/Cleveland scene was the same. It has long been a regional sound, yet it's oddly a little different from what you'd get up north in Cleveland. Perhaps the activism at Kent State—and, of course, the reverberation from Kent State's May Day clash between students and the National Guard that left a handful of students dead—had something to do with it. There was a little more art school vibe to it as well, even if it wasn't created by art school students.

Chris Butler (of the Numbers Band/Tin Huey/the Waitresses/Half Cleveland) was and is a promoter, and a self-proclaimed one for that matter, of the region's music and culture. Butler is not only one of the originators of the "Akron Sound" but also even started and published a fanzine called *Blank* in the 1970s that attempted to document its earliest years—this means he used to promote his and his friends' bands. More importantly, after reading a few Christgau articles in the *Village Voice* about the punk scene in England, Butler fired off a letter to him suggesting he ought to take a look in his backyard, as there was a lot of great music going on here in the United States. To Butler's surprise, he got a response from Christgau that he was coming to Akron and wanted to see some shows. Butler's cohorts in Tim Huey had to throw together a showcase event very quickly at JB's for the New York critic, but more on that later.

Nick Nicholis, lead singer of the Bizarros and owner of Clone Records, had also sent Christgau a joint album his label had released with his band on one side and the Rubber City Rebels on the other. So the New York City journalist was at least intrigued by the sounds coming out of Akron—especially after he gave the album an A- in his review of it.

Because of his visit and article on the visit, as well as major label releases by Devo, Tin Huey, the Rubber City Rebels, the Bizarros and others, the idea of an "Akron Sound" came about, and the phrase stuck. You'll find people using it all the time these days, which is good, as it helps out curator Wayne Beck and archivist Calvin Rydbom (which is me) get people interested in the "Akron Sound" Museum.

From where I sit, I don't know that there was ever really an "Akron Sound" in the sense that any of these bands sounded the same—or even were punk bands. I think it was more of a case of a bunch of bands that simply sounded unique and original and didn't want to be cover bands or work in rubber factories—the latter part was a very important factor. Nobody would mistake the Rebels for Devo, the Bizarros for Chi-Pig, the Numbers Band for Unit 5, the Action for Hammer Damage or the Walking Clampets for Tin Huey. But most of them certainly sounded unique. If you want to make the argument, which I will at some point, that the swarm of talented originals bands created more originals bands, then we might have something. And they created an audience in the area that began to expect something different than what they heard on the radio—that I'll agree with you on. But an actual sound like Seattle's grunge movement? Not so much. Not at all really.

As for them being "punk"? Maybe the sense of aggression was there. Maybe that feeling of rebellion was there. In certain cases, the anger was clearly there—Devo is the most deceptively angry band ever. But this wasn't the Sex Pistols or the Ramones sort of overt anger. No, Devo was far more clever than that but no less confrontational from the stage. "New wave" doesn't fit it either. Just different; it was just Akron. Just some really cool music by a bunch of young musicians who didn't want to follow their folks into the rubber factories. I mentioned that already, didn't I? The joke has been made many times that there was just something in the water. Most of the musicians in this story have been asked about it so many times that they've given it a fair amount of thought, with no clear answer truthfully.

Buzz Clic, the lead guitarist for the Rubber City Rebels, once told me, "I don't think any of the bands sounded alike, but I think the spirit was the same. We were all just sick of being spoon-fed the music of the day and it appeared that the seat assignments were already taken, so when the 'punk/

new wave' thing came along…well, there was a wide open door, and we all just went through it." I think that defines the "Akron Sound" more than anything else I've been able to come up with.

I'm not the first to decide to spend some time shining a light on this, of course. Filmmaker Phil Hoffman has done two great documentaries on the "Akron Sound": *It's Everything, and Then It's Gone* and *If You're Not Dead, Play!* And Devo has had a few great projects about them filmed or written. Lately, Jade Dellinger and David Giffels's *Are We Not Men: We Are Devo!* is fantastic and a must read.

So, how did I become part of this story in my own small way? I was born in the area, for one, in a town called Stow, situated between Akron and Kent. I was a little too young for the first wave of the "Akron Sound," but I caught the second wave when JB's in Kent was still going strong and so many great bands were holding court at the Bank in downtown Akron. I was hooked at that point, not only by the bands out of Akron but also by music in general.

And yes, I was in a "punk" band, or at least what some middle-class kids from the suburbs of Akron thought of as punk, although Lux Interior of the Cramps was also from Stow and seemed to do okay. So perhaps it was a matter of us not being that good. We called ourselves Radioactive Scum from Mars, a respectable name for a suburban punk band in 1981–82. It was supposed to be funny. We played out once, and at a venue mentioned in this book, during our senior banquet in high school. They threw our entire high school out while we were on stage. Yes, my claim to fame as a punk musician is that I had a mic removed from my hand and was told I needed to vacate the stage and the facility by the venue's security—a rather large security guard, if memory serves. The drinking age was eighteen in Ohio at that point, and by the time we got to Kent, there was a bar giving a free pitcher of beer to anyone from my high school. Oddly enough, it was not the bar known for being a punk/new wave haven but rather the one known for showcasing bands doing Van Halen, Zeppelin and Bob Seger covers. But it was free beer.

There were some later, and equally bad, bands through my early twenties that went nowhere. There have been attempts to revive one on several occasions, but thankfully I've been able to dodge that bullet. Although honestly, some former bandmates have recorded some decent stuff. Maybe I should dust my bass off…or at least reattach the knobs on it. So many bands in the late 1960s and early 1970s have the Velvet Underground to blame for forming a band. We in Akron, and I personally, had the Rubber City Rebels and Devo. But as my musical talent is sketchy at best, I write about it instead.

But anyway, I moved up to Cleveland. I opened a camera store and then two more. Then digital came and I closed my three stores, which found me at loose enough ends that deciding to obtain a master's in library science at Kent State made sense. I started working as an archivist and writer and published a few books dealing with topics involving Cleveland. Just three years ago, Akron was well in my rear-view mirror, but then fate brought me back to Stow. A casual conversation with an editor I had worked with in the past about needing to change my physical address, as I was now a Summit County resident, became a conversation about me writing a book to be called *Modern Akron* for Arcadia Publishing.

The more I dove into the topic, the more I knew a cornerstone of the book had to be Akron's music history—so much so that it wound up as its own chapter in the book. And I've been told it was also its best received and what drove sales at the local stores.

Over the years, I've written quite a bit on music, mostly for a British website called Toppermost. It was there that I introduced Tin Huey and the Rubber City Rebels to England.

As part of the whole process of putting the chapter in *Modern Akron* together, I met Jimi Imij. Imij is the lead singer for the punk band 0DFX (who are definitely a punk band), along with several other bands going back decades. Imij is also a (probably *the* if we are being honest) longtime chronicler of the Akron music scene. His collection of memorabilia was and is amazing.

Now, while Imij was helping me with *Modern Akron*, he was also helping a longtime fan of the "Akron Sound" and frequent patron of the Bank in its heyday. Wayne Beck and Imij had done a temporary exhibition on the "Akron Sound" at the Summit County History Museum, using Imij's collection. It was a pretty big hit, and folks from around the region visited it during the exhibit's run.

So, Imij naturally brought me and Beck together, and the idea for a permanent location for a museum took form. Over the last year or so, Beck and I have amassed more than six hundred items for the museum. Many have come from the musicians themselves—and probably just as much from the people who came to see them. As of this writing, the "Akron Sound" Museum's Facebook page has fans from seventeen countries. It's hardly just an Akron, Kent and vicinity thing.

We've had a number of pop-up museums and hope to have a permanent brick-and-mortar location by the time you are reading this. As it is now, the "Akron Sound" Museum is alive and well online on Facebook, Instagram and Twitter. We'll also have our collection online by year's end and look

forward to the collection growing by leaps and bounds. If you want to look at, as well as read about, Akron's music history, visit the "Akron Sound" page on YouTube; just search for "Akron Sound" and a channel with a few hundred videos will come up. Many were shot by Imij in the early 1980s. Another exciting project is with Cleveland State, which will be hosting our collection in a website as part of its regional memory project. You'll be able to find that at http://www.clevelandmemory.org/aks.

So, why Akron? Some great music came out of it. Why this book and a museum? Because the music deserves to be celebrated and preserved. And why me? Because I was at the right place at the right time and found myself discovering awesome bands and people whose passion for music is driving me right now. It's a passion that a few years ago I never would have guessed would become my obsession, even though I had seen a handful of these bands thirty years before. Writing about music has become my passion since, as I mentioned earlier, I was no good at making it.

ACKNOWLEDGEMENTS

I offer deep thanks to all those who helped in the creation of this book, for better or worse. Special thanks to Rod Firestone, Mike Hammer, Dave Zagar, Ralph Carney, Jim Carney, Tracey Thomas, Bob Ethington, Jerry Parkins, Nick Nicholis, Jane Ashley, Debbie Smith, Kal Mullens, Gavin Whitehouse, Robert Kidney, Michael Purkhiser, Tricky D, Larry Gladden and so many others. For always being on call and never voicing what had to have been their growing annoyance that I never stopped calling, special thanks go to Buzz Clic, Harvey Gold, Don Parkins and Chris Butler. I thank Jill Bacon Madden at Jilly's Music Room and Dick Robbins for their support of the museum and music in general. Jimi Imij and Wayne Beck can't be thanked enough. Thanks also to The History Press and everyone there for their help.

INTRODUCTION

Akron was never really known as a creative center for music before the explosion in the 1970s that created the scene and the sound this book is all about. There have been Akron-born or longtime residents who had success over the years. But they really didn't have much impact on what became known as the "Akron Sound," at least from the perspective of the musicians who made up that era. Some did though.

Helen Jepson was raised in Akron and was a soprano for the Metropolitan Opera in New York City from 1935 to 1941. Her performance in *Porgy and Bess* was actually supervised by George Gershwin, and she was the first soprano to perform the role. But she had roots here. Her father actually owned a confectionery store while her family lived in Akron. So they were certainly a part of Akron, its history and business world for a time. Besides, working with Gershwin needs to get a mention.

Vaughn Monroe's time in Akron was also short-lived. While he was born here in 1911, his family moved across the border to Pennsylvania while he was still a child. But he was Akron born and arguably, although largely forgotten now, the biggest musical star to come out of Akron. From 1940 to 1956, the trumpeter and singer notched more than fifty Top 40 singles, as well as five number ones. Unfortunately, his career ended with the onset of rock-and-roll, and he died fairly young in 1973.

While not an Akron native, Louis Jones began his musical career while living here as a teenager. Jones first started singing on WJW radio before being discovered and becoming part of the Pine Ridge String Band, which

handled the singing duties for the popular radio series *Lum and Abner.* Jones became known as "Grandpa Jones" not long after leaving Akron and became extremely well known in the 1960s and 1970s as a long-running member of the television program *Hee Haw.*

Joe Glazer was an Akron transplant. The folk singer was very connected to Akron during his years here, though, as he began performing for the United Rubber Workers before becoming its education director from 1950 to 1962. Glazer had a long career as a politically motivated folk singer, and his albums recorded in conjunction with the Industrial Workers of the World were anthems to the factory workers, who felt strongly that management didn't quite have their best interests at heart. Many of those men and women would become the parents of the musicians this book is about.

Another popular folk singer (this one Akron born) who had success in the region was Len Chandler. He started out as a classical musician, joining the Akron Symphony Orchestra in the early 1950s while still in high school. He earned a degree in music education at the University of Akron before moving to New York City and eventually becoming involved in the civil rights movement and establishing himself as a writer of some of the harder-hitting folk songs of the period.

Russel Keys Oberlin was referred to by the *New Yorker* as "America's first star countertenor" and was a major figure in the revival of Medieval and Renaissance music in the 1950s and 1960s. Oberlin was born in Akron in 1928 but was at the Juilliard School of Music by 1948 and made his base New York City after that.

Lola Albright is best known as the nightclub singer in the groundbreaking *Peter Gunn* television show in the 1950s and 1960s, although she appeared in countless movies and television shows well into the 1980s. Albright worked as a receptionist at WAKR in her teens before beginning to perform on WJW. If you've never seen *Peter Gunn*, you should; television didn't get any more stylish than that in the 1950s.

Ruby Nash was Akron's first star who sang in a style that would eventually find itself lumped under the pop/rock umbrella. Nash was an R&B singer who in her late twenties joined a male singing group they renamed Ruby and the Romantics. They signed with Kapp Records and had a number one hit with the still well-known "Our Day Will Come" in 1963. During the next few years, they were often found on the mainstream and R&B charts. Nash returned to Akron after the group disbanded in the early 1970s and lived here for years, working for AT&T and Goodwill. The band won induction to the Vocal Group Hall of Fame in 2007 and has received numerous similar

awards over the years. Nash has resisted performing live again over the years but left behind a significant legacy as part of the first Akron band that had big success recording music targeted to the youth culture.

In the late 1960s, a few musicians in the emerging rock world came out of the Akron/Kent area, Joe Walsh being one of the bigger ones. One band that came out of the Kent State scene was, of course, the James Gang, fronted by Walsh. Some people have focused in on Walsh as the guy who made it right before the whole scene happened and was a blueprint for all these other bands. Oddly enough, the only time Walsh came up in hours and hours of interviews was during a story Chris Butler told me about JB's ownership agreeing to let them do a showcase there but only if they agreed to play there after they hit it big and not do it like Joe Walsh, who hadn't been back in years. But in all fairness, Walsh was in the Eagles at that point and a bit busy with arena-size tours and all.

Harvey Russel had quite a following in town as the "Singing Policeman," being backed up usually by a young group known as the Rogues, whose leaders would go on as (Jerry) Buckner and (Gary) Garcia and have a success after they left Northeast Ohio. They are best remembered for "Pac-Man Fever" at this point but have written number one country songs, and Buckner is currently involved with creating music for the *Wreck-It Ralph* franchise.

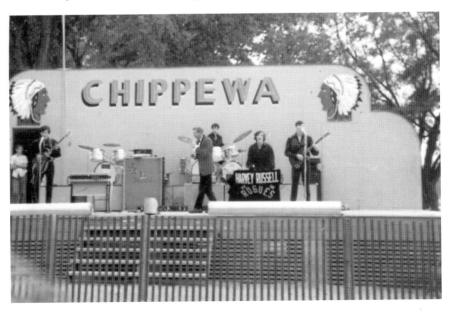

Harvey Russell and the Rogues at a festival in the late 1960s. The large amp on stage, named Super Measles, belonged to Joe Walsh of the Weasels. *Courtesy of Jerry Buckner.*

But the high point of Akron music before the punk and new wave movement hit town was the Howard Street jazz scene. I really can't do justice to the jazz music that came out of what was the African American and minority area of Akron. The clubs there booked stars like Count Basie, Cab Calloway, Billie Holiday and Wes Montgomery. For a time, Akron was a significant quick-stop hot spot between New York and Chicago for big national acts. Akron had a number of its own players, though. Punch Atkinson, Duke Jenkins and Jimmy Noel were part of the Howard Street scene for years at clubs like the Hi-Hat and APS Club. That jazz scene deserves its own book, really, and there was talk of a *Legends of Howard Street* movie a few years back, but much like the "Akron Sound," it really hasn't gotten its due.

So while there isn't a direct lineage from much of this music to Devo, the Bizarros, Tin Huey or the Rubber City Rebels, it's certainly important to realize that there was some good music that came from this town before all these sons and daughters of rubber workers began strapping on their instruments or stepping behind their drum kits—or, in some of their cases, duck calls, chainsaws and whatever Devo was doing.

PART I

THE PLAYERS

THE NUMBERS BAND (15-60-75)

In reality, the Numbers Band (15-60-75) wasn't really part of the "Akron Sound" era. They were more akin to big brothers who did a whole lot of what the other bands eventually did—but they did it first. I've read claims that they were the first to trot out mostly originals on the Kent strip, and until someone tells me different, I'm willing to accept that as a fact, as they arguably paved the way for bands like Devo, the Rubber City Rebels and Tin Huey. In fact, members of two of those bands were part of the Numbers Band (15-60-75) before they became integral parts of their own respective bands. Footnotes in the band's history, for sure, but it still says something about them being a cornerstone, especially considering how the two men left the band.

Robert Kidney had worked as a solo act around the area for a few years, opening for an equally young Linda Ronstadt and Janis Ian in the 1960s. Kidney left for Chicago for a short time but returned in 1969 and found himself opening for a band called Pig Iron, led by a friend of his, at the Akron Art Museum. The band members were impressed enough by Kidney that they asked him to come to one of their rehearsals sometime, seemingly to convince him to perhaps join the band. By the time Kidney did show up, his friend had left the band, and he found himself being encouraged to replace him as the new front man for the group. Kidney accepted the offer,

although the band's name was changed to 15-60-75 after a grouping of numbers used in blues historian Paul Oliver's book *Blues Fell This Morning: The Meaning of the Blues* in a chapter on the numbers racket in Harlem. For various reasons, though—the most obvious that it was much easier to say and remember—the name fans and clubgoers began to refer to them as was the Numbers Band.

In 1970, the band started playing at the Kove on a weekly basis. It was a large club and at the time arguably the most popular in Kent. Their first night there was only two months after the Kent State shooting, which for many musicians in this book was a large factor in the direction the scene took. Very quickly the Numbers Band (15-60-75) was playing in front of more than five hundred people per night. The lineup changed a bit during those early years, with Kidney and saxophonist Terry Hynde being the only consistent members. Those two, along with Kidney's younger brother, Jack, have continued to be the core of the band to this day, both creatively and in just showing up. By 1972, a fair amount of conflict had emerged within the original band, with some members enjoying the Chicago blues they were playing and others interested in moving more into the jazz genre. Kidney was intent on using a lot of the original material he was writing and adding his brother to the band, as well as being more than just a blues band. Some of the band felt that moving toward being an originals band risked the profitable enterprise the band had become.

In late 1972, Kidney essentially left the group, although in taking the name with him it allowed him to make his brother's band the new Numbers Band (15-60-075). Hynde, who is the older brother of the Pretenders' Chrissie Hynde, left to form a jazz band. And bassist Gerald Casale threw his lot in with the Mothersbaugh brothers and formed Devo, which seemed to have worked out for him, although he was out of the band for different reasons. The story varies, but essentially Casale donned a mask on stage during a show and made the crowd laugh. Kidney told him that wasn't the direction his band would ever take—comedy or even confronting the audience—but he thought that Casale was a talented guy and needed to go do his own thing.

The new version of the band allowed Kidney to start playing his originals, working in a lot more solos and playing with his brother, Jack. Hynde was back in the fold rather quickly, if he ever really left. The trio formed the core of the band that is an essential part of the Akron/Kent/Cleveland music scene to this day. Kidney got to "play" with his brother, Jack, and that's usually the word you'd use when musicians work together, but probably not Robert Kidney. Kidney took the job as a musician very

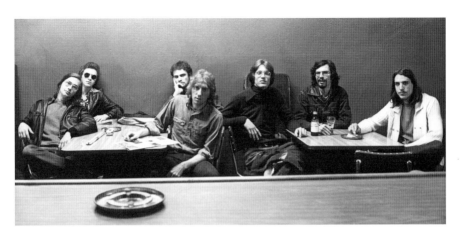

David Robinson (drums), Gerald Casale (bass), Mike Bubnow (guitar and bass), Bob Kidney (vocals, harmonica, guitar, keyboards), Hank Smith (guitar and keyboards), Terry Hynde (alto sax) and Tim Maglione (tenor sax). *Courtesy of Dave King.*

seriously; a band for him was not a weekend lark but a job that needed to be worked at and worked hard. Audiences deserved that. It wasn't play. It was more serious than that.

Bad luck ensued, though, as the Kove caught on fire not once but twice. And while there were other places to perform in town, for the band, a base of operations as impressive as the Kove disappearing just as their first album was coming out was a blow.

Jimmy Bell's Still in Town did come out, though, and the Numbers Band (15-60-75) has continued to soldier on for another forty years, although that probably isn't the best description, as the guys are still incredibly creative and their live shows are a must see. Kidney has been part of Anton Fier's Golden Palominos, and the brothers toured Europe with David Thomas of Pere Ebu. A great story, a great blues band and a Northeast Ohio icon, but how is a blues band, even one as experimental as Numbers, part of a musical movement whose other bands all had punk or new wave aspects to them?

According to Butler, though, they were certainly an influence. Butler—who along with a long tenure with Tin Huey and the Waitresses also published the early 1970s Kent fanzine *Blank*—spent a few years in the mid- to late 1970s as the bass player for the Numbers Band. Without hesitation, Butler will tell you that Kidney is the source for what came out of Akron and Kent in the late 1970s. He'll also tell you that while Tin Huey was the most creative group of musicians he's ever worked with, the Numbers Band (15-60-75) is the best band he has ever been in.

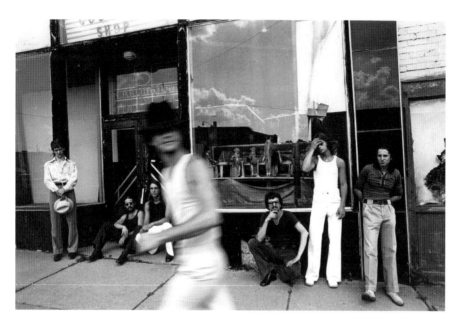

A shot intended to be used for an album called *Nobody's Jaun*. *Left to right*: Jack Kidney, Mike Stacey, Tim Maglione, Bob Kidney (walking through), Terry Hynde, David Robinson and Chris Butler. *Courtesy of Lance Karkruff.*

The current lineup of the Numbers Band (15-60-75). *Courtesy of Angel Casamento.*

It was more than just their success as an originals band that led to the opportunity for others to follow. More importantly, it made it feasible for clubs to book other originals-heavy bands. Butler pointed out that Kidney's blues foundation and Hynde's love of jazz created a band where they might start a song in a traditional way, but based on what Kidney was feeling, the song could go anywhere and soloists could be given all kinds of room to create. The improvisation, the originals, that something you couldn't get down the street at the bar where some groups were playing Top 40—it all conditioned the fans to hit the dance floor and demand from the band "Show us what you got," according to Butler and several other musicians who followed in their wake. Butler left the band in much the same way as Casale, as other projects that allowed him to work on his own songs conflicted with the exacting schedule of the Numbers Band (15-60-75). It reached a point where Kidney told him, "I can't give you what you want, kid," and let him go. Both that and Casale's story say something about Kidney as a leader: he knew talent and knew when it was time; they left because it was conflicting with his band, which was the important thing.

Another aspect of the Numbers Band (15-60-75) that Butler pointed out was that their musicianship was far and away beyond what a local band playing in a bar was expected to have. And again it set expectations among the audience. When they got to Los Angeles, the members of Rubber City Rebels were surprised how much better they were as musicians than the punk bands already in L.A. Butler claimed that when Tim Huey played New York City, he had the same experience.

With a changing group of faces, the Kidney brothers and Hynde have continued to be an integral part of the Northeast Ohio music scene long after the days of the "Akron Sound." The Kidneys have worked and traveled Europe, working with Dave Thomas of Pere Ubu. Robert Kidney was a member of the Golden Palominos for a while, bringing his songwriting to an entirely new audience. Over the last few years, they have also visited traditional blues while doing a Kidney brothers album, with each also releasing solo albums. Almost fifty years into the band's history, the guys are still drawing crowds and recording. Their impact is so far reaching that, at the moment, a local filmmaker is finishing a documentary on the history of the band and those same influences.

Whether the Numbers Band (15-60-75) really set expectations in the audience and thereby set things up for a group of musicians that followed them onto the stages of Akron and Kent in just a few short years is really anyone's guess. It's very easy, though, to connect those dots, as Butler said.

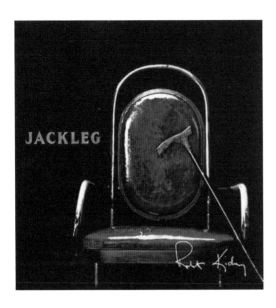

Robert Kidney's 2016 album,
Jackleg. Courtesy of Robert Kidney.

Regardless, they were by just a few short years the first band that played essentially originals with a different sound you didn't hear on the radio or in most local clubs. And right after them, those bands came in waves and got named the "Akron Sound."

Band Primer

The Numbers Band (15-60-75) have released several albums over the years, but they are a band who needs to be heard live to be truly appreciated. Their improvisational skills are a large part of who they are. Because of this, it's difficult to come up with a list of their songs you really need to go listen to, as they can evolve and be very different as Kidney works through a song on any given night.

"Animal Speaks" is off their first album, *Jimmy Bell's Back in Town*, recorded at the Cleveland Agora during an evening the band opened for Bob Marley and the Wailers. It starts off with an intermingling of the band's instruments in which they seem somewhat independent of one another but somehow find themselves meshing perfectly. "Animal Speaks" was covered by the Golden Palominos twice during the time Kidney was with them. It's also found its way back in their live shows of late, as it appears in the upcoming film *My Friend Dahmer* about serial killer Jeffrey Dahmer, who grew up in a suburb of Akron and committed his first murder there. Oddly,

Chris Butler, onetime bassist for the band (as well as for Tin Huey and the Waitresses), now owns the Dahmer house. Regardless, it's a great song.

Also from the first album is "About Leaving Day." The crowd shows some excitement at the start of the song, perhaps because it's a great opening or perhaps because it was a fan favorite by then. It's another great track on an album of great tracks. Kidney in some ways seems to be reciting a poem over a really interesting rhythm section foundation with an occasional guitar solo thrown in for good measure.

"Thunderhead"—which appears on their third album, *Among the Wandering*, in 1987—was a much older song in Kidney's catalogue. It also contains some of my favorite lyrics of his: "I dare not speak the secrets of my life/So in my dreams/They come at me like knives." The song ends with a somewhat shimmering, even ethereal feel for a Kidney song, almost calming after the anger that permeates the rest of the song.

"A Letter Back" is better known by most as a Golden Palominos song from their 1989 album *A Dead Horse*. The Palominos sound is considerably less experimental and blues oriented than Kidney's usual bandmates. But he spent a short time in the Palominos and recorded it with them. Their style gives the song a gentler, more reflective tone than most of his songs, although lyrically most are poetic in nature. It's a really different way to appreciate his songwriting skills.

"Back to Disaster," from Kidney's 2016 solo effort *Jackleg*, is another Kidney-penned song that sounds different than the classic Numbers Band (15-60-75) sound most associate with him. The album itself is an acoustic blues album, with Kidney playing only guitar with no accompaniment. It's classic blues in a way a song called "Back to Disaster" can only be. The album is a must listen just as much as the band's first release was thirty-nine years before.

THE RUBBER CITY REBELS

It's more or less a given that Devo is the most commercially successful band that came out of the "Akron Sound" era, although the Waitresses made a run at matching them for a short time. Both certainly sold a lot more than the Rebels. Likewise, other acts around town have had careers just as long as, if not much longer than, the Rubber City Rebels. Yet in many ways, the Rebels are the face of the late 1970s scene for a lot of Akronites who

remember the first wave of bands. Arguably, they are the band that really lit the fire in Akron music. Quite a few bands wound up being formed by ex-members after the Rebels ended their initial run or simply left the band.

The odd thing about the Rebels, though, or at least about their two longtime leaders and mainstays, was that they came from the suburb of Hudson, which is nestled between Akron and Cleveland. A nice play to grow up and live, to be sure, but not exactly a birthing place of punk or hard rock bands. While punk scenes across the world usually find themselves birthed from working-class neighborhoods, Hudson was never really a place rubber workers put down roots, although a fair number of rubber executives might have lived there. Akron musicians from the 1970s talk about growing up in dark, dingy Akron surrounded by abandoned buildings and clouds of smog. Hudsonites grew up in the shadow of the town square's clock tower, situated in its quiet and quaint New England–style downtown.

But it was there in 1972 that twenty-three-year-old Buzz Clic and nineteen-year-old Rod Firestone started playing together. Clic started a few years before Firestone playing guitar in a band called Bold Chicken, an interesting name for a band, surely, but a decided improvement over their first choice of Dead Leather. Bold Chicken had decent success as local bands go. They played a number of gigs at JB's, which is something that most bands of the era did if they were any good at all. They even found time to get into Keigers Studio in Akron and record some demos. Along with those demos, there are a lot of other recordings, as they usually recorded their practices. Some of those recordings eventually saw the light some thirty to thirty-five years later—in one instance when the owner of a small record label bought some masters at a garage sale.

Bold Chicken started to wind down in 1972. Clic, who owned the band's PA and equipment, was starting a band to play Top 40 music instead of originals like Bold Chicken. Firestone, who was friends with Clic by then, came over one night and politely listened to his friend's band. When they all left, he told Clic to fire all those guys and start a band with him playing fast and loud rock because what he was doing sucked. Clic figured he was right and felt he'd rather play in a hard rock band anyway. Both of the musicians were fans of bands like Status Quo, Mott the Hoople, Alice Cooper and Blue Cheer. In fact, given the opportunity, Clic will talk about how great Blue Cheer is to this very day. They were also both fans of the New York Dolls, a band whose existence most weren't aware of in 1972. Clic and Firestone were even both big enough fans to be in the Cleveland audience when New York Dolls opened for Mott the Hoople in 1973.

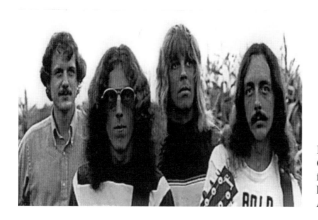

Buzz Clic's first band, Bold Chicken. Image taken in a field not far from where he lived at the time. *Courtesy of Buzz Clic.*

Meanwhile, another future member, Donny Damage, was playing with a popular glam rock band that was also way ahead of its time for Northeast Ohio: Fat Tuesday. They were flat-out glam with no apologies. Damage wore platform boots, sparkling outfits and makeup—unique for Ohio in every way. He became friends with Firestone and, for a short time, his roommate, which is somewhat ironic as the friction between Firestone and Damage became a common theme over the next thirty years.

When Clic and Firestone decided to form their new band, which they christened King Cobra, Damage was also invited to join. In those early years, Damage served as the lead singer, and Firestone played guitar along with Clic. They were originally joined by Scott Winkler and a short-lived drummer whose name nobody seems to remember. Damage does remember having a drummer perhaps named Jerry Shirley, although he was reasonably certain it wasn't the Humble Pie drummer, who had a ten-year career as a radio DJ in the '90s in Cleveland.

Whoever he was, the original drummer was replaced by Kevin Hupp, and King Cobra quickly made a name for themselves by covering Status Quo, Alice Cooper, KISS, Mott the Hoople, Nazareth and the New York Dolls among others almost every night from Cleveland to south of Canton. They had adopted the often over-the-top glam attire of Fat Tuesday and provided even wilder stage antics. People still talk about the nights at the Mustang in New Philadelphia and JB's in Kent when Damage took a chainsaw to a mannequin he had filled with all kinds of garbage during the band's version of Cooper's "Cold Ethyl." They were, as cover bands go, pretty hard. And the people who came out loved them. They were playing six nights a week, and they were the exception among cover bands since they were making a living doing so.

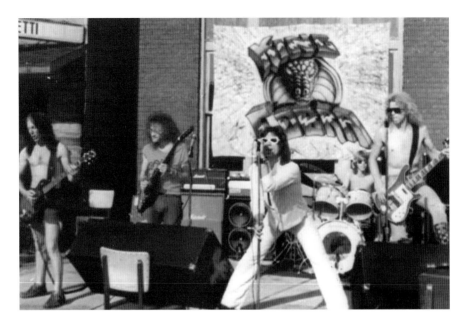

The band performing as King Cobra before the name and style change. *Courtesy of Jimi Imij.*

But Clic, Firestone and Damage were growing tired of being in that sort of band, even though they weren't actually known as Clic, Firestone and Damage at that point—or at least they probably weren't. Things really started to change in early 1976, when they went to a Heartbreakers show in Cleveland—the Heartbreakers that had Johnny Thunders and Jerry Nolan from the New York Dolls and Richard Hell from Television, not the Tom Petty backing band. Clic remembered the band being stoned on stage and pretty bad at the start of the show, but as the night went on, they became much better and actually produced something akin to music. But he still left thinking that he, Firestone and Damage were better than them since they weren't strung out, but being just as sure their style of music was cutting edge and what they should be doing. Damage stopped short at saying they were better than the Heartbreakers but agreed with his two bandmates that the emerging sound was the direction they should be heading.

Unfortunately, when they pitched the idea to Winkler and Hupp the next day, the rhythm section wanted nothing to do with the idea. Clic and Firestone remembered them being against the idea because the band was making pretty damn good money for a cover band and saw no reason to throw that way. Damage also felt that the style of music the trio was interested in had something to do with it, as they were both funkier

Buzz Clic at JB's while the band was still King Cobra. *Courtesy of Jimi Imij.*

musicians in his mind. Winkler did wind up rejoining Damage and future Rebels drummer Mike Hammer in Hammer Damage a few years later though. In the new lineup, Damage slid over to bass, and Firestone took on vocals on top of losing a drummer and bass player. It was a significant revamp for the band, in sound and in lineup.

Clic said that he wrote the band's first original, "Child Eaters," just to prove to Hupp and Winkler that you could write a song about a really stupid topic with just two chords (and then only because he couldn't figure out how to write a song with one chord) and people would show up to listen to it.

So, the search for like-minded musicians to fill out the band occurred. Pete Sake became the keyboardist simply because he heard what the guys were trying to do and wanted to be part of it. According to Clic, they were never really into the idea of having a keyboard in the band, but he had energy and they were just impressed that someone was willing to play with them. Sake had met the band a year earlier when he provided flash pots for a King Cobra performance. He had also been playing in his own bands for three years at this point. More importantly, he was a fan of the New York Dolls, Ramones and Patti Smith.

For the drummer, Clic reached back a bit and found Stix Pelton, who worked at a body shop in Hudson owned by the father of a member of his former band Bold Chicken.

At that point, in late 1976, King Cobra began playing regularly at a downtown bar known as the Crypt, which to that point had been mainly the kind of working-class bar people hung out at during the day; it was not known as a place to go hear bands at night. Its regulars were not that interested in bands, but the younger crowd at the time still talks about an early show the Rebels did with the Dead Boys and the Bizarros. A New Year's Eve show, and another on the first day of 1977, were big turning points for the band and the local scene. Devo, another future regular at the club, joined the Dead Boys and King Cobra for those shows.

Firestone and his girlfriend lived in the same apartment building as Mark Mothersbaugh of Devo. Of course, they would talk music when they bumped into each other and got to know each other fairly well. When King Cobra was at its peak, they had a truck full of the best equipment you'd expect an Akron cover band to have. And who better to be their sound man than the guy known as "Mr. Technology" in those days. Clic remembered King Cobra using a lot of special effects such as flash pots, but it didn't quite get the effect they wanted because they didn't make noise. So Mothersbaugh would make explosion noises with his keyboard. Eventually, he would add gongs, other explosions and any number of sound effects from his spot back at the board; he also wasn't beyond singing some backup vocals now and then.

As for when King Cobra became the Rubber City Rebels, that is one of the few memories most of the band members I've talked to remember somewhat similarly. It was on the suggestion of Stiv Bators, legendary front man and leader of the Dead Boys. After really liking one of the band's new originals, "Rubber City Rebels," Bators told them they should call themselves that, as it was a great name for a band. According to Clic, they came off stage for the first time after playing the song live, and Bators, who was off to the side watching them, said that should be their name and they could use it as their theme song. Thus the Rebels were born. They were looking for a new name anyway. Oddly enough, according to Clic, they hadn't considered Rubber City Rebels.

The Dead Boys had a huge influence on the band, easily heard when you listen to both groups at that point. The Rebels wanted the same crazy high energy the Dead Boys (formerly from Cleveland) had been unleashing on New York City since the summer of 1976. They also paid attention to the Dead Boys' use of stage names, along with bands like the New York Dolls and the Ramones. So the band was inspired to take on the names Buzz Clic, Rod Bent, Stix Pelton, Pete Sake and Donny Damage. It wasn't until later that Bent became Firestone. When that occurred, though, isn't all that clear. Just as hazy is when King Cobra made the switch from a cover band to an originals outfit, but it was before the band's name change. As Clic told me, nobody ever interviewed King Cobra, or asked their names, so he really had no idea when they decided stage names was the way to go. Firestone remembered becoming Firestone after their Los Angeles manager, Michael O'Brien, suggested it. But then again, he really doesn't remember Buzz ever being anything but Buzz. Forty-plus years between events and trying to remember them tend to confuse things.

Firestone and Damage on stage at JB's. *Courtesy of Jimi Imij.*

But King Cobra worked up a set of originals—or mostly originals, as a few reworked covers became part of their set list—and took to the stage at a local bar they had performed at in the past. The bar, known as the Crypt, became a short-lived but legendary spot in the Akron punk scene. Many top-tier bands, local and otherwise, performed there. In a somewhat remarkable turn of events, the Rebels actually found themselves running the club and being able to book whomever they wanted to perform alongside them after the owner told them that as long as they kept up the lease payments, the place was theirs.

During the early morning and day, the bar had a steady flow of regulars, but at night the owner had started booking bands in an attempt to bring in more bar patrons later in the evening. Clic remembered setting attendance records at the bar while they were still King Cobra. But then again, he also remembered the bar struggling to hold 150 people. The story has been told so many ways over the decades, but at its core, the tale goes that the owner offered to let them run the bar since they were the only ones who made any money there. Firestone later realized this wasn't exactly true, as during the band's short-lived management, it was the daytime regulars whose drinking paid the bills. The owner was tired of the grind, and depending on whom you talk to, there was also a strike going on or he was working

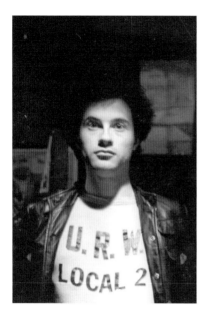

Firestone wearing the kind of shirt even punk rockers wore in a bar across from Goodyear. *Courtesy of Jimi Imij.*

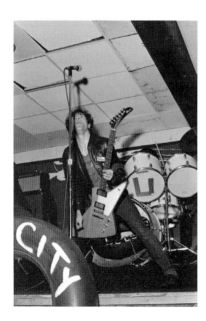

Firestone at JB's. *Courtesy of Jimi Imij.*

forty hours a week in a factory already and simply wanted out. Or perhaps, as some suggest, his wife wanted him to get out. Up to then, the Crypt had been a rubber workers' bar directly across from the Goodyear plant on Market Street. It was actually located in the basement of the building, with a men's bathhouse directly above it, as well as a diner. The walls were black, painted with all sort of oddities, and the place was illuminated with black lights.

Firestone jumped at the idea of running a bar, although he remembered that the rest of the band were a bit hesitant. The deal lasted less than a year, but it did wonders for the Rebels and the local music scene. Firestone remembered it being almost a year, but Clic thought it was six months tops. But all of a sudden, Akron had a club where these bands that were starting to get a following could play whenever they wanted. So along with the Rebels, you could go see Devo, who was just starting to get national attention after appearing in the 1976 short film *The Truth About De-Evolution*, which got them noticed by rock icons such as David Bowie after it won some film prizes outside the area. Along with them, Pere Ubu, the Bizarros, the Dead Boys and other bands long forgotten also found themselves having a stage in Akron to perform on.

A few months into 1977, the Rebels went into a local studio and recorded a handful of tracks. Unfortunately, the band was unable to pay for the studio

time and the mastering of the tapes, so they wound up being abandoned. However, that particular version of Rubber City Rebels recorded at the studio somehow wound up on the *Akron Compilation* album put out by Stiff Records a year later.

Running a bar wasn't proving to be that lucrative, especially, as Firestone and Clic both pointed out, since Devo was the bar's biggest draw and the band's fans were mostly art school students who drank juice and never ran up the kind of tabs that pay a bar's bills by drinking the twenty beers per night Firestone was looking for. So, when Bizarros lead singer Nick Nicholis started his own label with Clone Records and came up with the idea of a split album between the Bizarros and the Rebels, to be called *From Akron*, it seemed a great idea as yet another, albeit cheaper, way to get the band's name out there, especially as they didn't really have to pay anything out of pocket to actually have a record out.

The band recorded its songs at Bushflow Studios, owned and operated by Tin Huey member Marc Price. Bushflow was not state of the art, but for a studio situated in a house in Akron, it got the job done. A lot of Akron bands, and a number of Clone Record releases, got recorded at Bushflow. The setup at Bushflow had the mixing board upstairs and the recording studio in the basement. The engineer, that being Price, couldn't even see the band. But the Rebels' experience there wasn't to their liking, nor was it to the liking of anyone else at the studio that day.

Harvey Gold of Tin Huey remembered the conflict being something about how the hard-rocking Rebels were drinkers and the more oddish art rock Price and his team were pot smokers, and the two cultures more or less clashed. As Price struggled with his equipment (and whether it was weed induced is up for conjecture), Damage got more and more annoyed. He felt that the atmosphere was killing the energy of his band. Finally, he decided that urinating in the corner of the studio seemed like a good idea as a way to show his displeasure. Price, of course, didn't allow them back after Damage's protest, and they had to finish out their side of *From Akron* in a different studio.

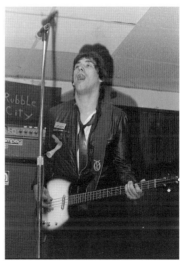

Damage at JB's. *Courtesy of Jimi Imij.*

Damage remembered Firestone being pretty angry at him for being that unprofessional and removed him from the album cover as punishment. Clic, though, remembered Damage deciding to quit the band, something he did fairly regularly at the time, according to Clic, and Firestone being very angry about him doing so at a critical moment for the band—angry to the extent of having Clic redo all of Damage's bass parts and removing Damage from the album in every way.

Unlike a lot of the other bands from the era, the Rebels more or less have gone their separate ways, with a few reunion shows and tours here and there over the past thirty-five years. Bands like Tin Huey, the Bizarros, Devo and the rest have stayed together, or at least stayed friends and therefore in constant contact. It seems because of this that many of them have a collective story and memory, but the Rebels do not and frequently have somewhat divergent versions of their history.

Clic looked back at some of Damage's differences with him and Firestone's direction for the band now with humor. He remembered Damage coming to practice spouting that this punk thing was the wrong direction—if they want to make money they should become a *disco* band. And the next day, he'd come in and say something like, "If I ever suggest become a disco band again, just punch me in the face." Regardless of what happened, in some ways the friction drove the aggression of the band in the studio and on stage—certainly the latter, where so many people rave about the band's live performances, even calling them the best live band they've ever seen.

Damage was back in the band in about a month, which is how it usually played out, according to other members. But as to why exactly he isn't on the split album, there are a few different versions. Harvey Gold of Tin Huey remembered meeting Damage for the first time a few years ago when he walked up to him at a Tin Huey gig, offered him his hand and apologized for pissing in their studio. At least he assumed it was Damage, as Gold hadn't met many of the Rebels by that point.

But while the energy from their collective friction might have helped the original three members, they were having problems on other fronts. They wanted to play loud and fast, and Pelton simply wasn't a fast drummer, and it was showing. Things worked themselves out, though, when Firestone and Clic had an argument that reached a point where Clic actually walked away from the band for a few weeks. Clic remembered the argument as being serious but, at the same time, not really all that serious. It was the same thing they always tussled about: Clic was a hard rock guitarist, and Firestone wanted a punk band with music that was a bit simpler, much more

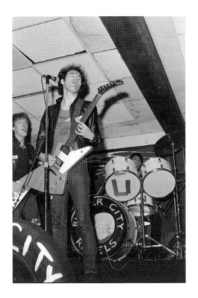

The band at JB's. *Courtesy of Jimi Imij.*

like the Ramones, than Clic liked to play. Clic pointed out that it's easy to see their differences when you look at songs written by Firestone and songs written by him. Of course, as he also told many over the years, he loves "playing an aggressive punk style. I just didn't like being told what to do."

Clic brought Pelton along with him in the idea of supposedly forming another band. According to Clic, though, he knew that he was going back to the Rebels pretty quickly—it was all a way to ease out his friend Pelton, whom he had brought into the band, while still maintaining the friendship. A few weeks later, Clic was back in the band and Pelton wasn't.

In the spring of 1977, Mike Hammer joined the band, first performing as a Rebel at Geauga Lake, a local amusement park. The band was on the bill with the Dead Boys and UFO that day, and Hammer cemented his place in the group by providing the fast-paced and skillful playing that Pelton could not. Hammer was only a teenager when he joined the band. He answered a newspaper ad for a drummer, started arguing with Firestone within a minute and wound up hanging up when Clic tried to intercede. A few days later, he called back after hearing a radio ad for the Geauga Lake show where the guys were opening for UFO and the Dead Boys. When Hammer realized that this band was actually doing something, he figured they were worth playing with.

It was also around this time that Clic and Firestone decided that running a bar wasn't really their forte, in large part because the owner had sold his liquor license to a Holiday Inn. They happily found themselves with a band that could move around the country at will, which they did initially by serving as an opener for the Dead Boys at New York's legendary CBGB's. Sake was still with the band at that point, but his time was also coming to an end. If you had talked to the people in the audience at Rebels shows at the time, many would have told you the Rebels had to get rid of Sake because the band's sound and a keyboardist were mixing less and less. The band was also very excited about the idea of moving to California, and supposedly Sake wasn't really interested in doing so.

Clic, though, refused to budge from the story that they were having a practice at his home when Sake called them and said he couldn't get out of work and wasn't going to be able to make it that night, which wasn't a big deal, according to Clic. However, Clic's wife came in a bit later with burgers for everyone and told them she had run into Sake with his girlfriend and they were going to see the light rock duo Seals and Croft at the local music amphitheater Blossom Music Center. Clic remembered how he and Firestone turned to each other and simultaneously said, "Rubber City Rebels don't go to see Seals and Croft." And with that, the Rebels no longer had a keyboard player. Clic also remembered, "Rod and I could be kind of full-of-ourselves assholes back then."

That story has made the rounds over the years, but sometimes with the band being the '50s nostalgia group Sha Na Na. Sake's last gig with the band was probably during the CBGB appearance in July 1977, and Sha Na Na played Blossom on August 2, while Seals and Croft played there August 3 and 4. So while the real story might be a mix of a few reasons, the "going to see a not-so-punk-approved band" is plausible. And Clic stood firm that it was all about him going to see Seals and Croft.

While Sake was angry at the time, the years have mended the relationship, as he now plays with the band at an occasional reunion gig in Akron where he still lives. And when the Rebels left town, he formed another popular Akron band, Teacher's Pet, with his brother, Kal Mullens.

Not too long after all this occurred, Clone Records released the *From Akron* split album with the Bizarros. The album wasn't exactly a hit, but Nicholis did send a copy to *Village Voice* critic Robert Christgau, who played a large part in the "Akron Sound" story multiple times along the way. He reviewed the album very positively, which was justified as it was the Rebels at their most primitive fury, although the recording quality and mix weren't really all that great by today's standards, maybe even 1977's standards.

Oddly enough, the band was considerably different by the time the album was released: no keyboardist, a new drummer who was a significantly better fit—altogether a faster and louder band, albeit in a more polished but still definitely punk sort of way. They were also, and this was important to their later sound, a more skilled and tight-sounding band than most of the punk bands that were trying to bust out. So, with these advances, they moved to Los Angeles in late 1977.

Not that it matters, but it was probably around this point that Rod Bent finally settled on Firestone. Clic said that the original idea was to change all their names to be related to tire companies, such as Pete Michelin or Buzz

Goodyear, but only Firestone followed through, which is probably for the best. The fact that Clic remembered keyboardist Sake as part of this idea, proposed by their Los Angeles manager O'Brien, makes you question the story and timeline, like so much of the Rebels' history.

So, the Rebels, or at least some of them, left Akron for Los Angeles. For some of the band, the move was short-lived. The band trickled out to the West Coast, with some going out first to check it out. And while some people encouraged them to go to New York City, after growing up in Northeast Ohio, the warmer destination made more sense to the band.

They found themselves with the band, wives, roadies and all their equipment jammed into a small apartment in Venice, California. The wives got jobs at a local supermarket, and a somewhat creative way of ringing up the band's groceries allowed everyone to eat.

Firestone remembered them not getting a gig for a while, other than maybe one at the Starwood, until they pulled what he called their "billboard" deal. The band commandeered a billboard as a publicity stunt and had everyone around town talking about the Rebels. Some, though, place the stunt only *after* they had become a very popular band on the Sunset Strip, often playing the Whiskey a Go Go. In that version of the story, it was the billboard that pushed them over the hump and got them signed by Sire Records. In reality, it had more to do with the Rebels just being so much better musically than the other early punk bands in L.A. Years of playing together in King Cobra and in Akron just made them a better band. And they certainly wrote songs in the more traditional ways. It wasn't just attitude. Their songs had bridges, intros, guitar solos and more that the other bands just didn't have the experience to achieve.

What happened next still features the hallmark of the band in that there are several versions of the event, and even though they do get together, they don't even talk about it to this day. Clic told me that the Sire deal falling apart is still a sore subject within the band, to the extent that they still don't talk to one another about it—whether it was about a few band members and their management insulting Seymour Stein, the head of the Sire, or the Los Angeles management arguing against going to New York and making sure the deal got sunk. Or it's also possible that Sire dropped some of its new punk acts when its other recent signings like the Dead Boys and the Ramones weren't getting any radio play, all while the new wave acts like the Talking Heads were. Regardless, they had a deal and then they didn't.

Whatever happened, it created a bit more friction in the band than usual. Although the location differs depending on who is telling the story, the band

had a meeting—Clic and Firestone were going to head back to L.A. and keep being a top band on the Sunset Strip while looking for another label, while Hammer and Damage decided to move back to Akron with the promise of coming back out if another label signed the Rebels.

Firestone also told me that the band covered for its disappearance from the L.A. scene for a while by putting out a press release saying they were going to tour England. It seemed to have worked, as when they got back to L.A. people kept asking them how England was.

When Clic and Firestone did get back to L.A., they brought aboard two local musicians, Johnny Besthesda and Brandon Matheson. Meanwhile, back in Akron, the returning Rebels were busy forming Hammer Damage, becoming popular in their own right. Firestone felt that the new guys helped the band a lot, as they had so many local contacts that the Rebels had been lacking. The biggest was Matheson's relationship with Doug Fieger, the lead singer of the Knack and with whom he had previously been in a band. Fieger and his band were riding high with the debut of a self-titled album featuring the number one song of 1979, "My Sharona." So, when he became interested in the band and decided to produce the Rebels' initial album, his label, Capital Records, got involved. But while the album was critically well received, it never really sold well. Firestone felt that nobody really knew how to slot them. Were they punk, power pop, hard rock? It didn't matter to them, but some of the band did feel that it was a hindrance that they couldn't be slotted easily.

The band, with the L.A. additions, played on for a while and even made a small appearance in the film *Tag: The Assassination Game*, starring Linda Hamilton and Robert Carradine. But for the most part, they faded away as the band members themselves started finding other projects.

So, a decade or two went by until 2001, when a remastered version of the Capital Records album with bonus cuts was released. It was quickly followed in 2002 by the album *Re-Tired*, which featured a group of live cuts as well as their half of the *From Akron* album. So Clic, Firestone, Damage and Hammer found themselves together again, doing a number of dates centered on the two new releases. The initial show at Akron's Highland Square Theater was an amazing return to form, and to Akron, by the classic four members.

Following the script that had been performed several times in years past, Damage left before the reunion shows were over. He was replaced by Clic's brother, Bob Clic, who also played bass on their 2002 album *Pierce My Brain*, which placed the single of the same name on the 2003 Tony Hawk skateboarding game.

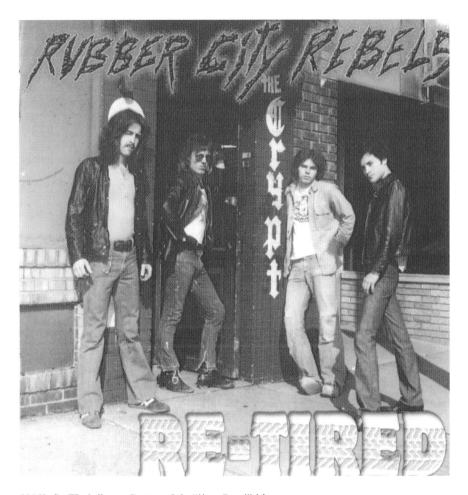

2002's *Re-Tired* album. *Courtesy of the "Akron Sound" Museum.*

Shortly after those releases, the two Clics, Firestone and Hammer toured both Europe and Japan, later returning to Europe on a few separate dates. Firestone was most impressed by the experience of the tour of Japan. He remembered playing in Oakland and meeting three young Japanese men who had come to Oakland just to see the Rebels and interview them for their fanzine. He remembered during the interview that they asked the band if they wanted to come to Japan; if the Rebels were interested, they would book the shows and handle everything. Firestone remembered telling them sure, not thinking that anything would come of it. But then a few weeks later, plane tickets, money and a list of dates showed up with dates in Osaka,

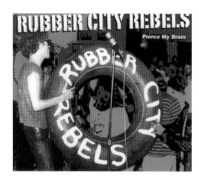

The Rebels' 2003 album, *Pierce My Brain. Courtesy of the "Akron Sound" Museum.*

Tokyo and around the country. When they got there, they were surprised at how popular they were. They found themselves doing a record signing at a store that had its entire window full of Rebels memorabilia. It was an amazing experience for the band.

There have been reunions here and there and a single release named *Annoyed, Destroyed and Unemployed* in 2011. Buzz Clic still performs as the Buzz Clic Adventure in Los Angeles, and Donny Damage still plays in a few Akron bands but has mostly returned to his initial love, the blues. Firestone has a real job, as he told me that jobs that don't involve being a rock star actually pay. And Hammer, like Firestone, lives in the South.

Firestone told me that the Rebels were an interesting case, as they came so close many times regarding a few different record deals. They were one of the biggest bands on the Sunset Strip. They shared the stage and hung out with just about everybody in L.A., but they just never got over the hump. But they are still guys from Akron because they never got over that hill and never got corrupted because they never made it. But they still lived the life.

Band Primer

The Rebels came roaring off the vinyl on the B-side of the *From Akron* album with the Bizarros. Like any good punk band, they started with a 1-2-3-4 countdown before just throwing themselves into "Kidnapped." It's ferocious, it's attacking, it's even fun. Punk with keyboards and a sense of fun—who knew that could work?

The second song on the album, "Such a Fool," features some really slick guitar work and even what comes damn close to guitar solos. It is also one of my favorite Firestone vocals. It's classic punk, but it's also toe tapping.

And how could they go wrong with a song called "Rubber City Rebels"? It starts out with Clic on his guitar just sustaining before the drums and bass just attack you; the song goes on for two and a half minutes before there is a break of sorts, and then it changes genres before it starts building back up to a great punk song—or proto-punk, or whatever the Rebels were at that point.

By 1980, they had a much cleaner sound, as they were on their third lineup and had added some other influences to their initial punk leanings. Hammer and Damage were definitely hard rockers, and perhaps their departure and replacement changed the sound a bit. Their second album started with a cover of the early Fleetwood Mac song "Someone's Gonna Get Their Head Kicked in Tonight." Firestone definitely found a rockabilly sound to some of his vocals, and the band had become a really tight-sounding quartet as opposed to the wild-sounding quintet from just three years earlier. It's two and a half minutes of fun. They were a bit different—not better or worse, just different.

The second song on the album was another cover: "Paper Dolls" by Jack Lee. They again had seemingly drifted away from their earlier growling attitude, although the aggression was still certainly there. But it was one tight unit. "Caught in a Dream" was another great cover. In fact, it was good enough to show up on an Alice Copper tribute album years after the band's first breakup. By this time, Clic had developed into a first-rate guitarist and really gets to stretch it out and show it on this song.

"I Wanna Pierce My Brain" could be a bit tongue-in-cheek—hard to say. But it certainly sounds like the Akron Rebels more than it does the Los Angeles Rebels. Much more aggressive than the slick and tight sound they developed in L.A.

"Born Dead" launches in what we think of as classic punk as well. Three minutes of power and aggression.

"Your Television Lies" might be my favorite late effort by the Rebels. Both energetic and a little pissed off. There is even a little bit of a message snuck in there.

In 2011, they released "Annoyed, Destroyed and Unemployed." It proved that punk, or at least the attitude, is not dependent on age; it's a great tune. They were still full of the fire they first showed thirty-four years earlier.

TIN HUEY

Perhaps of all the bands that came out of the "Akron Sound," it is Tin Huey that defies classification the most, even aggressively so. On the national, even international, landscape, music fans or even casual listeners clearly remember Devo as the oddly unique band from Ohio. And they certainly were, but the Hueys took second place to nobody in the sense of having a unique sound or, better yet, reason for existing—or, for that matter, talent.

When *Village Voice* critic Robert Christgau first saw Tin Huey at JB's UP in the spring of 1978, he wrote, "Tin Huey's music is also impure, but in a different way. With influences like Robert Wyatt, Ornette Coleman, Henry Cow, and Faust (the group, not the hero), they're Akron's esoterics, and like Liam Sternberg, who insists that no New Wave can break in 4/4, they value technique. This is not the kind of band I usually like. But where most groups use difficult keys and meters to get closer to Atlantis, or transubstantiation, Tin Huey seemed to be seeking the eternal secret of the whoopee cushion." And while I'm not sure how accurate the Whoopee cushion line was, it was fairly accurate and pretty funny, so nobody has really challenged the definition too much.

Much like so many bands, Tin Huey didn't start out with the name they finished with. Originally, they were known as the Rags, or at least as the nucleus of the eventual band known as Rags. Formed in the early days of the 1970s, they set out to be a power trio, albeit an odd one, of course. The band—made up of future Hueys Mark Price on guitar, Michael Aylward on bass and Stuart Austin on drums—became known for their twenty-minute versions of songs like the Who's "Substitute" or Paul McCartney's "That Would Be Something." They were a bit different with the Hueys, and not just for the style of play, as in the band Price would play bass and Aylward would be one of the guitarists. Price was known in guitar lingo as a shredder. When the band eventually hit their stride, he had become the guy who held the band together on bass. And had his own recording studio, a very important thing for the Hueys.

Not long after Rags started playing out and about in Akron, a young man named Harvey Gold, who up until then had been playing in groups such as Willie (named after a cat) that covered Buffalo Springfield, put on a pair of headphones and gave "White Light/White Heat" by the Velvet Underground a spin on his friend's turntable. According to Gold, it truly changed everything for him, especially regarding the kind of music he wanted to create and play, and just like that, he found himself the organist

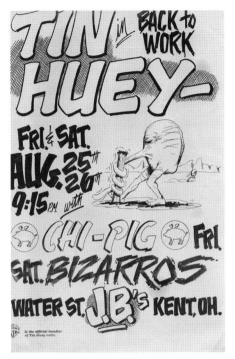

Left: Poster for Tin Huey. *Courtesy of the "Akron Sound" Museum.*

Below: Tin Huey right after Ralph Carney joined, playing a house party. *Courtesy of Harvey Gold.*

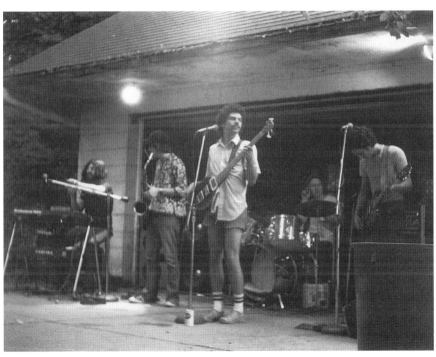

for Tin Huey. Although Gold isn't really sure where they scared up an organ, he suspects it belonged to Jerry Buckner of the Rogues, Wild Butter and Buckner and Garcia, who eventually hit the national Top 10 with "Pac-Man Fever."

Rags is remembered in Akron as not just being the precursor to Tin Huey but for once performing a "historic crazy as shit forty-minute set," according to Gold, at the Avalon Coffee House at the corner of Brown and South Street. The Avalon was owned by Craig Yoe, who became the creative director for the Muppets and now owns Yoe! Studios and has written and published an incredibly impressive list of books on and about the comic book industry.

Gold also remembered connecting with a musician from an earlier generation of Akron at the Avalon when he lent his guitar to David Allen Coe, who showed up to the coffeehouse for a gig without a guitar. Gold went outside to smoke but reported that Coe was polite and appreciative when he returned the guitar—more importantly, he didn't break it.

But then various reasons caused Price to step away from the band, although it turned out to not be permanent. The new trio of Gold, Aylward and Austin started moving away from the Rags sound, influenced by some of the more obscure folk artists of the time, as well as T. Rex's "Ride a White Swan." They went acoustic for a while and changed their name to Tin Huey, named after Aylward's young brother. They also started writing some originals.

Tin Huey very quickly added guitarist Arthur Baranoff and bassist Wayne Swickly and switched back to electric. Both left fairly quickly, to be replaced by the returning Price and saxophonist Lochi Macintosh.

During this time, Gold remembered playing at the Viking Saloon in Cleveland when an agency rep was in the audience. After the show, the rep sat down with them and told them they were really good but needed to decide if they wanted to do it the easy way or the hard way. The easy way was playing a lot of Top 40 and, as they built a following, working in their originals. The hard way was to keep doing what they were doing. According to Gold, they had no choice: Tin Huey did not become a cover band. As Gold said, "We were too twisted."

Instead, according to Gold, the band more and more became heavily influenced by a number of European groups such as Faust, Amon Duul, Caravan and the music scene that was occurring in Canterbury. In 1974, Macintosh left the band and was replaced by Firestone High School grad Ralph Carney, and Gold bought himself an electronic keyboard. Carney's

memories of joining the band involved working at a record store in Fairlawn's Summit Mall with Gold and being approached with a, "Hey, our sax player quit. Do you want to play with us?" The band and Carney's mutual friend Jim Kaufmann had actually introduced them and suggested him as a new sax player as well. At the time, Carney was also playing in a jazz band with future Devo member Alan Meyers and future Chi-Pig drummer (and then trumpet player) Rich Roberts. But he joined the band, which he thought played cool stuff but was really loud. Tin Huey, as a quintet, played around Northeast Ohio, becoming a little more offbeat with each show. And even though the number of shows they did wasn't high, they shared the stage with Rocket from the Tombs, the Mirrors and the Styrene Money Band. Luckily for them, they settled in playing three nights a week at JB's up on Kent's Water Street, where many believe the area's willingness to listen to bands playing originals rather than covers began. It was there the band really honed their sound. As Carney put it, while practicing is great, a musician really grows when he plays before a live audience.

The Numbers Band (15-60-75) held court downstairs, and JB's was known as the spot that launched Joe Walsh's the James Gang, so it was a great bar for a steady gig, even if it was during the slow nights of the week. According to Tin Huey, though, the only reason they got a three-night-per-week gig on a JB's stage was because the upstairs bar manager was a Grover Washington Jr. fan, and when he saw that the Hueys featured a sax player, he was sold on letting the band play in his club.

And they did hone their sound. They joked, even though the band members assure me it wasn't exactly true, that when they realized what little audience they had was about to start dancing, they'd bust in a 5/4 rhythm shift and screw them over to keep them from dancing. The band's goal became about shaking things up when they played. According to Gold, it was all about musical insurrection, whether it be in the music or in lyrics. In fact, they rather enjoyed normal music with screwy lyrics or completely off-kilter music with very normal lyrics.

Price had started up Bushflow Studios within his own house, allowing Tin Huey to release a single and an EP. Nick Nicholis of the Bizarros had recently formed his own label, Clone Records. And Tin Huey's recordings were released on the label, giving the young band their own recording studio and a friend with a label, a band's dream. Because of the popularity of Devo, Akron was starting to draw some national attention. But the Hueys knew that they were still an oddity in the States, so much so that according to Gold there was serious discussion about relocating to Europe and making

a go of the circuit on which some of the less mainstream bands over there were finding success. They were well aware that they were never going to become rock stars with the music they played, but it seemed conceivable that they could at least make a living overseas. Still, here they had a few releases out and an appearance on Stiff Records' *Akron Compilation*.

And then along came Chris Butler. According to Gold, "We just had this interesting synergy and began pumping out material and working the band like slave masters." Butler has gone so far as to say the only person he has ever been able to write with is Gold.

Butler had been playing around Kent for a few years by that point with some smaller bands and then as a member of the Numbers Band (15-60-75). He had recently been fired by the Numbers Band, as his many other interests were taking time away from the group, even missing practice, which was a cardinal sin to band leader Robert Kidney.

Butler was busy putting out a fanzine called *Blank* and releasing his solo work under the name the Waitresses on Clone Records. Later, Butler would turn the Waitresses into an actual group with some fairly well-known songs, but at this point it was a distraction from his work with the Numbers Band, and Robert Kidney didn't allow distractions in his band. He told Butler, "I can't give you what you want, kid."

One of the distractions might have been going to see Tin Huey, which like the Numbers Band was still holding court on one of the JB's stages a few nights a week. So, when Butler found himself bandless, and with some encouragement to join up with the Hueys by Carney, it wasn't that long before he found himself back in a band again.

Butler told me he really resisted joining a band. After his experience in the Numbers Band, he wanted to work as a solo artist of some kind. But he kept finding himself over at the Huey's rehearsals every night. The creative energy in the room just enticed him, even though he tried to deny it. Butler will tell you to this day that the Numbers Band was the best band he was ever in but that Tin Huey was the most creative bunch of people he has ever been around. So, he eventually convinced himself to join another band—for the betterment of the Hueys, of course, as the Gold/Butler combination is still going strong close to forty years later.

Butler was a promoter as well. He had been sending letters to Robert Christgau of the *Village Voice* about the region and its music. He chastised Christgau for writing piece after piece on and about New York City and English bands while ignoring all the talent that was in his own backyard, or at least in the Midwest. The way Butler remembered it, he fired off a letter to

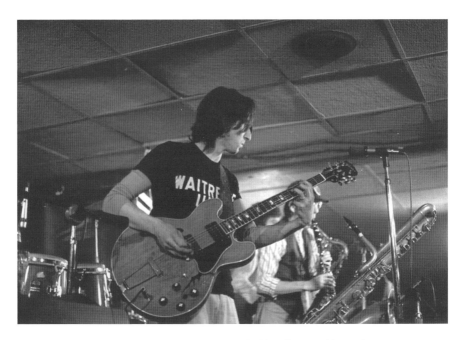

Tin Huey at JB's. Notice the "Waitresses Unite" T-shirt. *Courtesy of James Carney.*

Christgau after he wrote an article called "You Have to Deal with It, It Is the Currency" about the Clash and the English punk scene. Butler wrote him to say, "This is great, but you should look in your own backyard. There is this huge scene going on in Akron. We have Devo, we have Tin Huey, we have the Numbers Band. We have a whole street in Kent, Ohio, where every bar has a band in it doing originals. Playing original music where thousands of kids going from around northeastern Ohio to hear them." Nicholis had also sent Christgau a copy of the split album from the Bizarros and the Rubber City Rebels called *From Akron* that he had released on Clone Records. This and a number of other influences, such as the emergence of the Dead Boys and Pere Ubu from just north of Akron, convinced Christgau that there just might be enough talent out there to justify a series of articles he was supposedly going to call "Down in the Boonies." Christgau then agreed to see what was going on in Akron. He told Tim Huey that he was coming to town in two weeks.

According to Gold, Butler had only been in the band about three weeks, but together they were actively changing the whole nature of the Huey structure, dynamic and show. Gold remembered things just becoming "electrified."

So, the band quickly threw together a Friday night show at JB's for Christgau using word of mouth and the fanzine *Blank*. At that point, the Hueys were playing somewhat less than sold-out shows on Sunday, Monday and Tuesday at the popular bar. It took some talking to get the club owner to turn over a profitable Friday night to the band—and to convince the Bizarros as well, who would also play the show. According to Chris Butler, the owner only agreed if they promised when they became big they didn't forget to come back and play his club the way Joe Walsh had. So, as well as their other moves, they put fliers all over the area, according to Gold. They managed to drum up a fair amount of support so they could generate an audience to give Christgau the illusion of an incredibly happening scene when he showed up on Friday, March 10, 1978.

According to Christgau's article, which appeared in the *Village Voice* on April 17, 1978, it became the biggest Friday night in the history of JB's. According to the article, "A Real New Wave Rolls Out of Ohio," the Bizarros and the Hueys killed it. Christgau was especially impressed by the band's newest members, Carney and Butler—the former because he was a "remarkable young saxophonist" who wasn't above playing a duck call and the latter because Christgau felt he brought an R&B sensibility to the group and played three instruments; he also loved a few of his songs. It was a big success.

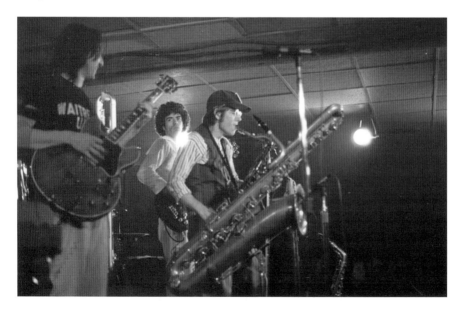

Tin Huey, with Ralph Carney's sax eclipsing the stage. *Courtesy of James Carney.*

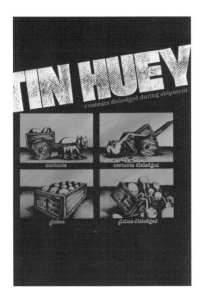

The cover for Tin Huey's *Contents Dislodged During Shipment. Courtesy of the "Akron Sound" Museum.*

Christgau was so impressed, especially as Tin Huey didn't really play the sort of music he usually enjoyed, that he invited the A&R head of Warner Bros. Records, Karin Berg, out to check out Tin Huey. And so the band, at breakneck speed, put together another weekend show at JB's. Again they swore an oath to the club owner, and again they recruited a bunch of people to come and support the band in a way unlike they did at the group's usual Sunday night gigs.

Gold remembered doing a killer first set that was so good that Berg asked him if the band had legal representation, suggesting someone for them when they didn't because she was about to sign them. Gold also remembered sort of being out of it after that and doing a decidedly more mediocre second set. Luckily, it wasn't so bad that Berg changed her mind.

A few weeks later, though, a third Tin Huey packed show had to be generated, this time because Berg wanted to bring Jerry Wexler, the head of Warner Bros. Records in New York City, along with Michael Ostin, the son of Warner Bros. president Mo Ostin. Also in attendance was Wexler's son, Paul, who eventually produced the Huey's first, and only, album for Warner Bros. After the Huey's set, Butler and Gold tried to talk Wexler into going downstairs to see Butler's former bandmates in the Numbers Band (15-60-75). It still bothers Butler almost forty years later that no matter what he did, Wexler wanted nothing to do with seeing any other bands and just wanted to go get dinner.

So, in the summer of 1978, another Akron band headed out to the West Coast to make an album, this time *Contents Dislodged During Shipment*. Now, there have been a fair number of stories over the years about how the album got its name. But according to Gold, who should know, he and his wife always had Stouffer's frozen French bread pizzas in their freezer. One night, during the planning of the album, he noticed the box had a warning: "Contents may become dislodged during shipment." He realized that the warning pretty much described what the Hueys were to him, in both intent and results. When the band received the first acetate pressing

of the mastered albums, they arrived warped beyond comprehension. So, it seemed that fate was backing up the band's name choice. When they sent photos of the damaged masters back to the record company, it seemed the label didn't quite comprehend the joke, a foreboding sign.

The band had great fun making the album in L.A. They hung out with Captain Beefheart, as well as saw him perform. You can clearly hear a Beefheart influence on the band long before they met him, or at least you can if you choose to. The big Akron connection was that they were able to attend the famous Devo kickoff gig at the Starwood.

Contents Dislodged During Shipment was released in the spring of 1979, when the record industry was in a major period of upheaval. They had knowingly made a non-commercial record for a record label that suddenly had its heart set on all their bands actually selling. But in the era that ended pretty much the weekend the Hueys completed their album, the record industry was flush and fairly comfortable with taking chances. The year 1979, though, saw the record industry crash. The band always felt that Berg was well aware that their first album, and even their second, wouldn't sell much. But what first drew her to the band was their incredible live show. As with most Akron bands, people were blown away by Tin Huey's live performances. Berg's plan was to put the band on the road constantly over the next few years and

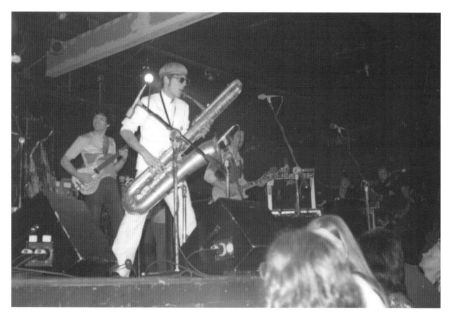

Tin Huey at the Bank. *Courtesy of Jimi Imij.*

let them build a following she felt their live shows were sure to generate. In that way, it would only be a matter of time until the Hueys would generate some album sales. It might have worked in 1977, but not in 1979, when the industry no longer had the time or inclination for that sort of plan.

Butler felt that, at least in hindsight, they should have told Wexler they weren't ready to be signed. Come back in a year after we build an infrastructure and play somewhere outside of Northeast Ohio, he thought. Come back in a year so we know something other than how to get three hundred kids to come hear us in a bar. Just as importantly, give some time for Chris Butler to find his place in the band. But they didn't. Butler told me that if they would have had another year, the band would have been a lot more cohesive instead of all over the place, which is what he hears in their first album, even though, as he says, "there is gold there."

So, in the late summer of 1979, the Hueys and Warner Bros. negotiated a separation, and the band no longer had a record deal. According to the Huey's website, the negotiation was fairly long and drawn out, requiring two phone calls and about ten minutes. Even though the band had an option for a second album, nothing came of it. Gold remembered the record company coming to the band and telling them that for the second album, they needed more songs like the ironic power pop cover of Robert Wyatt's "I'm a Believer" (a song originally recorded by the Monkees without irony). It was a song that got a fair amount of airplay during its initial release. Gold felt that the record company didn't even get the irony and idea that the song was more or less a joke, but regardless of why, the band told Warner Bros. no. They stood firm that they were going to do the album they wanted to do and had started—some of the demos showed up on compilations some thirty years later. So a major record deal was no more.

The band took those demos, as well as recording a few new ones, and spent some time seeing if any other labels were interested in releasing the Hueys. They were not. So, for quite a few years, the Akron era of the Hueys ended.

Ralph Carney was feeling a little bored with the entire Tin Huey project and had been making some connections with other folks, notably Don Cherry, Anthony Braxton and Karl Berger at the Creative Music Studio in Woodstock, New York. So Carney, with the assistance of Austin and Aylward, moved to Woodstock. After they helped Carney, they had planned to follow Butler and Gold to New York City. They never made it. Price alone had decided to stay in Akron and continue to run Bushflow Studios, which he eventually also relocated.

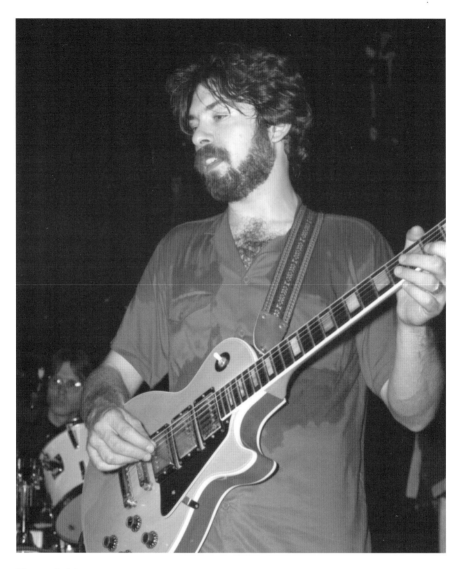

Harvey Gold on stage with Tin Huey. *Courtesy of Harvey Gold.*

Gold and Butler were in New York City mixing "English Kids" and "Sister Rose," which eventually would find themselves being released on Clone Records. During the mixing, short-term movers Austin and Aylward called with rave reports of the Woodstock area and offered a full-court press to convince the band to move there as well. Gold figured why not, but Butler decided that New York City was for him.

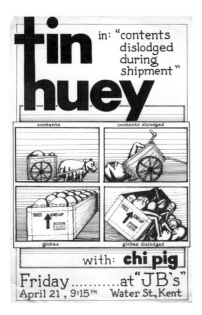

Poster for Tin Huey's "tour" of Northeast Ohio after the release of *Contents Dislodged During Shipment*. *Courtesy of the "Akron Sound" Museum.*

So, in November 1979, roughly six months after their first major label release, the band found themselves without a record deal and somewhat splintered with Gold, Carney, Austin and Aylward in Woodstock, Butler in New York City and Price back in Akron.

There were a few years where various incarnations of the band—even with the inclusion of members who did not grow up in the shadow of Akron rubber plants joining the lineup—gigged and recorded and sort of did stuff before taking a break that resulted in the band not really being together in any true sense of the word for years. They all stayed in the music industry, though, with Gold and Aylward spending time working for Todd Rundgren at his studio. The position included, in Gold's case, driving other musicians to grab the train after showing them around the studio and encouraging them to record there. One such afternoon involved Gold and the Kinks leader Ray Davies lamenting to each other about the state of the respective bands—Gold later realized that Davies was talking about a first-ballot Rock and Roll Hall of Fame group and he was talking about some weird guys from Akron.

During the period, Butler found some commercial success with his former side project the Waitresses, which Butler refused to admit to me had a hit; he argued that he remembered their highest-charting single to have peaked at 41. But who doesn't remember "I Know What Boys Like," a song whose genesis came to Butler at Akron's Bucket Shop. He also produced records for a number of people, including acts such as Joan Osborne. He got involved in music for TV shows, most noticeably the cult classic *Square Pegs*. And he served as musical director and house band leader of *Two Drink Minimum*, a Comedy Central show produced by Gold. Carney was also in the band for the show.

Gold had moved to New York City and started a video and film production service called Gold Teleproductions, which allowed him to produce and direct a number of television products and put his friends in his house band.

Price moved Bushflow Studios to the more lucrative San Francisco and was successful there while moving into the field of digital video.

Aylward and Austin continued working in the Woodstock area as a guitar maker and with Rundgren, respectively.

Carney went on to play with several national acts, including Tom Waits for a number of years. He has released a few solo albums and done music for television.

But then the universe sort of moved the planets in alignment for the Hueys when a rather long list of events occurred to bring the boys back together.

Aylward and longtime Huey engineer John Mondl decided to gather up a number of tapes lying around and, with Gold and Butler's help late in the game, released *Disinformation* in 1999. Gold and Butler both moved back to Akron in early 2000 for different reasons not related to each other or the band. Butler's solo album, *Museum of Me*, was getting good notices on NPR and in *Rolling Stone* in 2001, and *Contents Dislodged During Shipment* was reissued as a CD on the Collector's Choice label. This was also shortly followed by the release of Carney's *This Is!!! Ralph Carney*. Finally, *Scene* magazine, for better or worse the region's entertainment newspaper, ran an article listing Tin Huey as one of the five bands its music editor would pay big money to see live.

It was then, in late 2002, that Carney came home during a visit and put together a *Ralph Carney and Friends* show at the fairly new Beachland Tavern in the Colinwood neighborhood of Cleveland. So, April 2003 found all six members of the band, along with the addition of "Bongo" Bob Ethington, formerly of Unit 5, joining the band for a few shows in the area, as well as a few more in the New York region.

Since then, the band, in all sorts of different incarnations, have performed together too many times to really list. Gold, Butler, Ethington and Chi-Pig bassist Debbie Smith formed Half Cleveland in about 2005. That band has had a few lineup changes, with various Hueys sitting in over the years, as well as Rich Roberts from Chi-Pig. The band has settled into playing a few shows per year, with Butler, Gold and Ethington being the constant members of the band.

Price unfortunately passed away in 2008 after a long battle with cancer. And while the band has played a few gigs, all fundraisers, under the name Tin Huey, the decision to not play under the name formally, with Price no longer with them, has held for almost a decade.

Some other archival recordings have been released since Price's passing. *Before Obscurity: The Bushflow Tapes* is named after Price's studio where they

Back cover of *Before Obscurity: The Bushflow Tapes*. *Courtesy of the "Akron Sound" Museum.*

Half Cleveland, featuring Gold, Butler and Ethington, at Jilly's Music Room in Akron, Ohio. *Courtesy of Calvin C. Rydbom.*

were recorded. And, of course, Half Cleveland, led by Gold and Butler, have kept Tin Huey in the public eye.

The Hueys were an important part of the "Akron Sound," albeit as a group that never had any intention of being anything more than what they were: a band that shook things up with little regard for being or becoming commercial. In that sense, the Hueys achieved far more than any other veteran of the "Akron Sound." As Gold said, "We were art rock for laughs, and we wanted to write what we'd want to write and play what we wanted to play."

Band Primer

"Cuyahoga Creeping Bent," off their 1977 self-titled debut EP, introduces a band that already knew what they wanted to be and who they were, at least after four years of playing and practicing their craft. The tune shifts back and forth between roaring rock-and-roll and melancholy sax. It was sonic and somewhat reflective at the same time. I say "somewhat" as the lyrics are delivered in a way that just screams meaningful, but if you actually listen to them, they are a little odd. Actually a lot odd.

"Robert Takes the Road to Liebernawash" from 1978's *Breakfast with the Hueys* is a song whose opening I can listen to over and over again; the bass and sax just snake around each other. This makes sense since it was a Price composition. There is another recorded version released later, but I find this more stripped-down version the far superior effort. The vocals dance through a sequence of singing, talking and yelling. Great tune. "My last day as a boy was spent coding rocks in a zoological garden below the water line" is an all-time favorite lyric, and I'm not 100 percent sure he says, "kidding." Tin Huey lyrics are hard to find.

Their first single from *Contents Dislodged During Shipment*, and the only Tin Huey single that ever touched the charts, was "I'm a Believer." It's clearly a cover of the Robert Wyatt cover of the original Monkees song, the Wyatt song not one of the better-known Monkees covers. No attempt to cover a hit song was ever found on a Tin Huey album.

"Hump Day" from the same album is a Chris Butler tune that has a frantic tone about it while somehow maintaining a pretty tight sound. It's a song about "Work Work, Work Work." As Butler says, "Idle hands are the devil's playground."

"New York's Finest Dining Experience" starts off with an almost classic rock riff that makes you think you are going to be hearing something you're

not. The Gold/Aylward composition shifts tone a few times, to the point that you feel like you are listening to a mash-up, albeit a seamless one, of a few different turns. Carney's sax, as always, is great.

They released a few songs in 1980, among them one of my favorites, "English Kids." It was a straight-ahead rocker more than most of their songs, but it still had the Huey bent to it.

"Almost Transparent" and "Living with Strangers" were released on the *Disinformation* album. "Almost Transparent" is an Aylward/Gold track that, in many ways, foreshadows the most popular new wave singles of the 1980s, and Carney's sax is as amazing as ever. Gold's "Living with Strangers" is an oddly pleasant piano piece for the group that manages to have sort of pissed-off vocals at the same time. Tin Huey excelled at that.

"Armadillo" and "Right Now, Betty White" came from some even later releases named the *Obscurity* series. "Armadillo" continues that thing the Tin Hueys did where it sort of sounds like two different songs mashed up.

THE BIZARROS

It seems that a few of the groups who made up the "Akron Sound" can lay a legitimate claim to being the band that was really the most significant to the era. Devo was the band that really broke out and made Akron a thing. The Rubber City Rebels were the band that owned the Crypt and gave so many bands a venue where they could play. Tin Huey had a recording studio that so many of the locals used. And with owning Clone Records, and being the ones who first introduced Robert Christgau and so many critics and deejays outside the area to what was going on in Akron, the Bizarros could also lay claim to being the band most significant to the era. Not that it really matters, mind you, but so many of the bands contributed in so many different ways.

The Bizarros were destined to be a band long before any of them really talked seriously about becoming one, although most were musicians to begin with. Don and Jerry Parkins are brothers, so they were in each other's orbits from the start. And Don Parkins met Terry Walker in second grade at Legget Grade School in Akron. They subsequently met Nick Nicholis at Goodrich Junior High School, so the nucleus of the band was already formed as they entered their teen years. They were simply a group of friends at this point; becoming a band would have to wait until they were in their mid-twenties.

"We were friends who hung out socially, which is actually all we did," according to Nicholis, but it was at a New Year's Eve party at Walker's house that he suggested that he and his friends put a band together. After all, they liked the same kind of music. He already had a few ideas in his head for songs, and the band that became the Bizarros found themselves together just a few days after the New Year's Eve celebration.

The band wasn't quite musically accomplished at that point, but they did own most of the instruments they needed. Walker owned a keyboard and guitars, and both of the Parkins brothers owned guitars. Nicholis initially wanted to learn how to play bass and fill that role in the band. He even owned what he described as an old bass that Don Parkins wound up playing at the beginning of the band's history. Nicholis described himself as too lazy to practice and become the band's bass player, so Parkins moved into the role that he still handles more than forty years later.

Another high school friend named Bill Routan owned a drum set, but his involvement with the band didn't go beyond a few practices and playing a house party. After that, the band went on what Nicholis described as their great adventure to find a drummer.

Before that happened, though, the band had already begun to take shape, at least in the sense of how they saw themselves as a band. They were one of a handful of area bands who were predominately an originals band from the beginning. While it became increasingly the norm very quickly, in early 1976 that wasn't always the case. Nicholis had a number of ideas before the band even had their first practice, but he wasn't up to reading or writing music in those early days. He hummed his ideas for the first few songs that they quickly made part of their set lists, all of which wound up on the initial EP with Gorilla Records. Jerry Parkins was able to pick up what he was going for and work at the music. The band eventually fell into the pattern of Nicholis writing the lyrics and the rest of the band creating the music.

Some of the band members recalled playing at JB's before playing at the Crypt. Nicholis believed that the Crypt may have been their first gig other than private parties. During this time, they also found their first real drummer in Marty Zelei, who appeared on the group's first EP. During the next few years, they played all over Akron and Kent, especially at the Crypt, of course, as they were part of those first shows with the Rebels, Devo and the Dead Boys. But they also took the stage at the Pirate's Cove, JB's, the Nite Club and the Robin Hood, as well as at Zelei's high school. Nicholis seemed amused years later when he talked about the band making Zelei's high school yearbook.

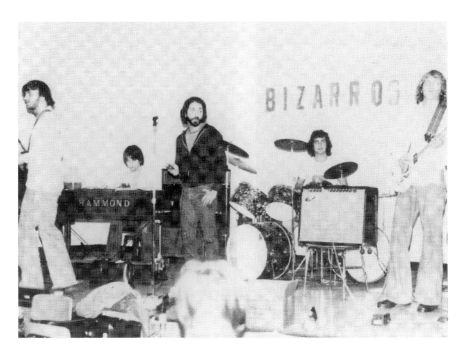

Promotional picture for a benefit show. *Courtesy of the Bizarros.*

Zelei didn't last too long as the drummer, though, and Rick Garberson settled in behind the kit for most of the band's original run, which included Nicholis creating his own label, Clone Records, to showcase the band in the hopes of a major record deal but that eventually wound up having sixteen releases during the label's short life.

Nicholis, along with Devo's success, probably first put Akron on the map musically when he sent the album *From Akron*, a split album the Bizarros did with the Rubber City Rebels, to Robert Christgau of the *Village Voice*. Christgau gave the album an A- and referred to the recording as a "pleasant shock," saying of the band, "The Bizarros' deliberate discordances (including viola, lest we forget John Cale) are carried forward on surefire junk-rock riffs; mastermind Nick Nicholis has the hang of Lou's deadpan songspeech."

It isn't much of a leap in logic to suggest that Nicholis sending Christgau the album helped grease the wheels for when Chris Butler of the Numbers Band/Tin Huey/the Waitresses subsequently sent the critic a letter that somewhat lectured him about how he really needed to check out what was going on in Akron and Kent. He did, of course, and it became a major event in the area being recognized as a hotbed for music.

The band fooling around in their practice space. *Courtesy of Russ Tripoli, the Bizarros.*

From a photo shoot done at Highland Theater in Akron. *Courtesy of Dan Opalenik, the Bizarros.*

Success seemed to come early and easily for a number of Akron bands after that, although that was ultimately deceptive. Devo, the Rebels, Tin Huey and the Bizarros all inked major record deals between 1978 and 1980. Nicholis remembered thinking that they had all made it big, talking with the other bands about their respective deals. But only Devo managed to release more than one album on a major label during those early years.

The Bizarros were signed by Blank Records, which was actually a label owned by Mercury Records, which had already released the first album by Pere Ubu, from just up the road in Cleveland. Pere Ubu had frequently played double bills with the Bizarros at the Cleveland Flats' entertainment hot spot on the Cuyahoga River, Pirate's Cove. They also advised Nicholis when he was setting up Clone Records and distributing the Bizarros releases, as they had done the same themselves just six months earlier. Mercury's Blank was set up a bit differently than most rock and pop labels and was more in line with a label that handled jazz, blues or classical. One of the big advantages of this kind of model was that the sales goals were set more with realism in mind and less with the idea that albums needed to go double platinum.

One of the A&R guys at Blank, someone who really seemed to love what the Bizarros were doing and the album itself, was Cliff Bernstein. He had also signed Pere Ubu and Canadian power trio Rush for Mercury, but more significantly, he went on to form Q Prime and has managed some of the top bands in the business over the past thirty-five years—Metallica and the Red Hot Chili Peppers being the most well known.

Unfortunately, while the band was finishing up their first album, a corporate shakeup occurred at Mercury, and Blank Records ceased to exist. Bernstein managed to get the album released on the Mercury Records label in 1979, but it had absolutely no support from the label, to Nicholis's recollection. It was not really interested in a band called the Bizarros in Akron in any way. There was a clause in their contract that they would receive a $6,000 buyout if Mercury decided to release a second album. And so the Bizarros found themselves with $6,000 and no record deal in 1980. Even worse for the band, Garberson passed away from carbon monoxide poisoning not long after the album was released.

After the death of one of his bandmates, as well as the Mercury deal falling through with no second album to be released, Nicholis decided that perhaps he had enough. He was thirty, or close to it, and the realization that he wasn't going to be a rock star had set in. And since he had a young family at home that he needed to support, he made the decision to get a

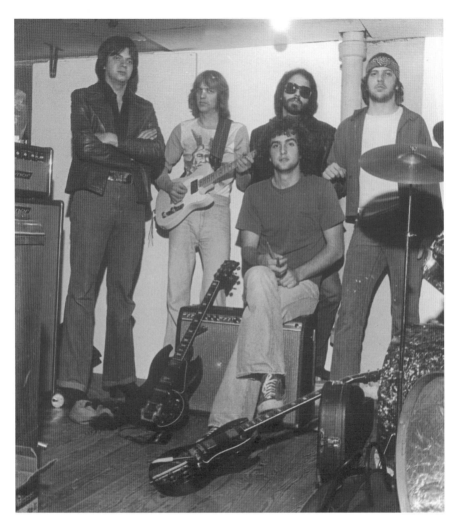

The band after practice one night in the late 1970s. *Courtesy of the Bizarros.*

real job and put an end to being in clubs with the Bizarros at 2:00 a.m. a few nights a week.

The band, at least Walker and the Parkins brothers, shouldered on by adding Kal Mullens, who eventually fronted Teacher's Pet and today the Bad Dudes. They, along with a few different drummers—including Dave Ashley, the brother of Jane Aire—shouldered on for less than a year before deciding to call it a day as well. But the four original band members stayed friends, and Jerry Parkins joined some other bands and kept playing steadily through the years.

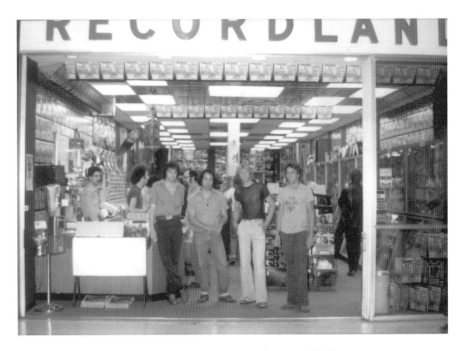

A record release event at Record Theater in Akron. *Courtesy of the Bizarros.*

A good bit of time went by before any serious music performing took place, much less songwriting, during the mid- to late 1990s. And it wasn't until Nicholis's fiftieth birthday party that the idea of the Bizarros becoming an actual band again was seriously considered. It seemed that parties brought out the best in the Bizarros, or at least dramatic changes in the direction of the band.

The search for a drummer was a bit easier this time around, as Jerry Parkins was able to bring along Martin Flunoy, with whom he had been playing for years during the band's hiatus. The Bizarros liked Flunoy, and he liked the idea of being a Bizarro. As he has been with the band for seventeen years, the idea seems to have been a good one.

In 2003, the band released their first album in well over twenty years, *You Can't Fight Your Way Uptown from Here*, which received some very good reviews, much better than their earlier releases. The album was released on Clone Records as a wave to nostalgia, and perhaps for luck, although it was in name only, as Nicholis didn't revive his label.

The band has played pretty steadily over the past decade plus and seems to be having a lot of fun with being a working band again. Nicholis feels

The Bizarros during a 2017 performance at Jilly's Music Room in Akron. *Courtesy of the Bizarros.*

that since nobody even considers the possibility of the band being signed at this point, it's just about gigging with your friends and other friends coming out to see you play. Now it's fun, as there's no pressure to make it. And while they take their performing and recording seriously, they don't seem to for much else. Their official website doesn't seem to have been updated since 2009.

The band, though, have recently reordered a new album and will be releasing it very soon. An album release party is planned in Detroit, and there are also some New York dates. Nicholis has an ambition to do a tour of Europe after everyone retires, a somewhat odd thing to say about a punk band. But it makes sense, as the Bizarros have quite a following overseas. I found out, amusingly, that the Bizarros don't have a Wikipedia page in the United States, but they do in Germany. An odd thing for a band whose bass player lives a few blocks from me in the suburbs of Akron.

Band Primer

The Bizarros came out of the gate on their first EP in 1977 with one of the cooler bass lines in the history of punk. It's so simple but just fun to listen to. It established the Bizarros early on as a group that had listened to a fair amount of Velvet Underground, as Nicholis did have a bit of Lou Reed in

his voice. "Lady Doubounette" was simple and a little understated, but the attitude was there. And it even had a cool little guitar solo and an amazing fade at the end. "I, Bizarro," from the same release, was a bit more growling and obviously aggressive; it's a song I love to hear live. The song ends with a prolonged musical section without any vocals, but by then you are just jamming and know the band has said everything it needs to say lyrically.

Their first EP is an amazing listen. "Without Reason" is another great song on the record. It has one of my favorite openings of a Bizarros tune, funky and punk at the same time. Much like last song ended with a long music exit, this one starts with a long music intro. There is this cadence that keeps going through the song, sort of like walking down the stairs, that really works. And, of course, there's another great solo. I know there has long been an unwritten rule that punk songs don't have guitar solos, but the Bizarros did, and they sounded great.

From their only major label release on Mercury, "It Hurts Janey" is a favorite of mine. Nicholis gets the snarl in his voice while still utilizing the talking-singing style that Lou Reed popularized.

"The Waves Cry," from the same album, starts out with a musical intro much like many of my other favorite Bizarros songs. There is also a damn good guitar solo in the song, but it has a very different tone than the others on the list. Regardless, it's a good song.

My favorite song of the Bizarros may be "Young Girls at Market," and it's another I can't hear enough live. Much like the two previous songs, there is a kind of repetitiveness to one part of the music, but not in a bad or boring way—more like the music is really pushing the car to go faster and faster by revving up the same chords over and over again.

"Another Desert Story," from the first *Bowling Balls from Hell* compilation of Akron bands, jumped out at me because I couldn't quite grasp that I was listening to a Bizarros song with backing vocals. It's very good, though, and an indication of where their music might have gone in the early 1980s.

"Underground" was released as part of a 7-inch single in France right before the Bizarros hung it up in the early 1980s. Nicholis takes a little different attitude in his voice, as there is a bit of tongue-in-cheek in his voice, maybe in the sense that he didn't quite believe the girl who says she is going underground. But it's different.

Jump ahead twenty years to the next Bizarros release, *You Can't Fight Your Way Uptown from Here*, and you'll be blown away by the opener, "1967–1977." It's a dedication of sorts to the bands who came right before the Bizarros and clearly influenced them, but it's very good. The thing that really strikes

me about the cut, and the album as a whole, is that while Nicholis's voice has changed a bit, the album sounds like it could have been recorded not long after "Underground." The energy and spark is still so obvious, and the guitar solo that outs the track is vintage Bizarros. It's the song that makes me say while "Young Girls at Market" may be my favorite song by the Bizarros, this is another candidate.

From the same album, "Helicopter Pilot" is another cut that I really get into, for no other reason than how it describes a helicopter coming down like a Klingon Bird of Prey.

The band's bassist, Don Parkins, told me that they have a number of songs recorded but never released. And they will be releasing a new album shortly. Not too long ago, they did a set at a show I was at of songs from the new albums. And there were a few I can see putting on this list. That's an amazing feat for a band with a forty-plus-year career that took a fifteen-year hiatus at one point. But give these songs a listen.

DEVO

Obviously the most well-known band to come out of the "Akron Sound" was Devo. Other than perhaps the Waitresses, Devo is the only one casual music fans at the time had ever heard of, as they were the only ones to get played on MTV. Not so obvious is that Devo is also the most misunderstood band to come out of the "Akron Sound," although some members of the band have always pointed out that they were a Kent band as opposed to an Akron one. Outside the area, and among people under forty-five inside the area, more than likely they are the funny guys in the jumpsuits that wore the masks and acted goofy. They were a lot more than that and a long way from goofy.

Devo came about largely because of the Kent State shooting on May 4, 1970. Bob Mothersbaugh, Gerald Casale and Bob Lewis were all on campus when the shootings took place. Mark was working at his art studio situated within walking distance of campus. Perhaps they would have become a band in some way otherwise, but so much of what the band was grew out of that time.

Two of Casale's friends, Jeffrey Miller and Allison Krause, died that day. He described himself as going from a hippie that day to someone who was "real, real pissed off." That anger channeled itself in the theory of "de-

THE DE·EVOLUTION BAND

Devo promotional image. *Courtesy of the "Akron Sound" Museum.*

evolution," the idea that instead of continuing to evolve, mankind had actually begun to regress, as evidenced by the dysfunction and herd mentality seen in American society.

Casale played in the Numbers Band (15-60-75) for a time, being fired from that band for wearing masks on stage in an effort to confront the audience. It was an idea that band leader Robert Kidney neither appreciated nor tolerated, although he thought of Casale then, and still does now, as a talented guy who just needed to go off and do his own thing. Casale and Lewis, along with Peter Gregg, recorded three songs in 1971 that were in many ways a precursor to Devo. The songs—"I Been Refused," "I Need a Chick" and "Auto Mowdown"—were recorded on fairly primitive equipment in Casale's apartment above Dayho Electric and Guido's Pizza at 405 Longmere, which has long vanished. Gregg went on to work as an engineer at Record Plant Studios in Los Angeles, as well as in several other positions within the music and television industry.

Those apartments were also ground zero for the "Akron Sound," as at one point Casale; Mark Mothersbaugh; Joe Walsh; Chris Butler of the Numbers Band/Tin Huey/the Waitresses; Bruce Hensal, who became the chief engineer at Criteria in Miami, as well as worked at Filmore West; Numbers Band saxophonist Terry Hynde; and Jon Zabrucky, who became a set designer for the film industry, all lived there. Butler, who was also a good friend of Miller's, was also at Kent State on May 4, as was Terry's sister, Chrissie, and feels that the shooting shaped some of his later work and the work of many musicians from Kent at the time.

Casale and Lewis created a number of art pieces using the idea of de-evolution as a catalyst. They met Mark Mothersbaugh around this time, who had been playing keyboards in the band Flossy Bobitt. He introduced Lewis and Casale to the work of B.H. Shadduck, specifically his 1924 pamphlet *Jock-Homo Heavenbound*, an incredibly odd work that references de-evolution and interesting ideas such as our ancestors losing their tails.

The band, or at least a band known as Sextet Devo, first performed at a 1973 arts festival in Kent. The band at the time included Casale, Lewis and Mothersbaugh, as well as Bob Casale, Rod Reisman and Fred Weber. Weber performed as a vocalist for several bands in the area during the time, and Reisman had been a drummer for the Numbers Band (15-60-75) for a short time. In the 1974 Creative Arts Festival in Kent, the band performed again, this time with Lewis, the Casale brothers and Jim Mothersbaugh joining his brother Mark. The band lineup ebbed and flowed quite a bit during the next four years, with Bob, a third Mothersbaugh brother, joining for a time. Bob Casale came and went as well. Unlike so many other performers, though, so much of their early performances were filmed, including their first two art festival appearances.

A few important events happened during this time. The first was when Mark Mothersbaugh befriended another musician, Rod Bent of King Cobra, who eventually renamed themselves the Rubber City Rebels; they also lived in his apartment complex. Jim Mothersbaugh left the band, and Alan Meyers joined the group.

Meyers joining the band accomplished two things. A period of stability began that lasted from 1976 to 1986. And for many, his drumming added a

Flier promoting Devo appearances. *Courtesy of the "Akron Sound" Museum.*

whole new dimension to the band. Meyers had been playing around town for a time and had worked in a jazz group with future Tin Huey saxophonist Ralph Carney and future Chi-Pig drummer Richard Roberts, who handled trumpet duties with the trio.

Akron native Todd Tobias, a multi-instrumentalist mostly with the Circus Devils and producer for many acts within the Guided by Voices universe and others, felt that Meyers does not get the credit he deserves for making Devo the band it became. "He made the music drive in a certain way, and those rhythms attracted me," according to Tobias. "He drove it in a primitive way behind Jerry and Mark's ideas."

Mothersbaugh's relationship with Bent evolved in a few ways. First, he became the sound man for King Cobra, running a lot of what the very successful cover band did from his boards. He produced sound effects, keyboard parts and even background vocals from his position off stage. And Devo even opened for King Cobra a few times before the band changed into the Rubber City Rebels. King Cobra guitarist Buzz Clic remembered them opening for them a few times at some of the more biker bar establishments that his band played at, including a place called the BBC. Clic remembered Devo setting up "those huge letters that spelled out DEVO" and that "Mark said it provided a level of protection in case someone threw something at them." During this time, Devo shows were often geared toward confronting and even antagonizing their audiences, so protection might actually have been needed.

When King Cobra found themselves running the Crypt bar in December 1976, their sound man's band was one of those they invited to play there on a regular basis, although Devo had been playing JB's in Kent before then. Clic also remembered what has often been called the fight between Devo and the Dead Boys and their fans that occurred over the 1977 New Year's holiday when his band took over the Crypt. His memory of it is as more drunken fun than a fight, as Dead Boys' Cheetah Chrome, who was perhaps a bit drunk at the bar, was egged on by his bandmates to sneak up behind the stage and essentially pants Booji Boy. What occurred after that involved Booji Boy and Chrome being face to face, with Booji Boy screaming, "Are you calling me a monkey?," as Clic remembered. But he recalled it being over and done with before the night was over. More importantly, it is something he still laughs about today and thinks of as one of the funniest things he has ever seen. He also found the idea of Devo and Dead Boys fans brawling with one another ridiculous, as the idea of Devo's juice-drinking art school student fanbase throwing punches with the Dead Boys' punk following was pretty funny.

Devo promotional image. *Courtesy of the "Akron Sound" Museum.*

Devo was taking off quickly. In October 1976, the band and director Chuck Statler released the film *In the Beginning Was the End: The Truth About De-Evolution.* The short film starts with shots of the Goodyear World of Rubber in Akron with the band at the time (Gerald Casale and the three Mothersbaugh brothers) getting off work and getting into a car. Mark Mothersbaugh was wearing the Booji Boy mask, and the rest of the band was wearing clear face masks.

The band drives to Kent, enters JB's and performs "Secret Agent Man" along with some very odd visuals. A second segment involves Booji Boy running through a parking lot on Front Street in Cuyahoga Falls and meeting up with General Boy, the Mothersbaughs' father. The short film won a prize at the Ann Arbor Michigan Film Festival in 1977. The wife of Tin Huey guitarist Michael Aylward slipped David Bowie some tapes of the band around this time, and Bowie, along with Brian Eno, decided that they needed to get them signed and produce their album. Which they did.

In March 1977, the band released the single "Mongoloid" with "Jocko Homo" on the B-side. Other bands in town remember Devo playing a bit hard to get with so many major labels chasing them, which was good for the community, as when these record execs descended on Akron, they figured they might as well hear what else was going on in town. Neil Young

asked them to be in his film *Human Highway*, which didn't get released until 1982. Stiff Records released the *Be Stiff* EP in late 1977, and a second self-released EP, *Mechanical Man*, also came out in 1977.

Devo's cover of the Rolling Stones hit "(I Can't Got No) Satisfaction" did fairly well in England, and when curious European music journalists asked about Akron, Mothersbaugh, in his memory, responded, "Oh, it's a factory town, overcast, gray, that it rains a lot—it's a lot like Liverpool." Of course, English music magazines such as *NME* and *Melody Maker* ran with "Akron is the new Liverpool," and another big moment in the "Akron Sound" timeline occurred. All of a sudden, especially with Stiff Records releasing the *Akron Compilation*, London clubs were having Akron Nights.

Then Eno flew them to Germany to record their first album at Conny Plank's Studio with the help of Bowie. Eno was sure that the band would be signed once the album was complete, although he and the group did clash creatively during the recordings. Devo seemed to find the Eno sound a bit out of kilter with theirs, but they did incorporate many of his ideas. Supposedly, though, Bowie remastered most of the tracks later.

A number of labels made offers to release the album, and they chose Warner Bros. here in the United States and Virgin in the United Kingdom, where Devo's initial albums did much better than in the States. Within a few years, though, the band was charting much better here than in the UK.

Devo was off to Los Angles after that and was really not a factor in the Akron landscape for years, as they didn't perform in any Akron venues for almost three decades. In all fairness, though, they didn't perform anywhere for quite a few years. Right before they left, Tin Huey member Harvey Gold, whose band signed with Warner Bros. not long after Devo, remembered sitting down with Mark Mothersbaugh and Gerald Casale to talk about doing a "thank you, Akron" show of sorts at the Civic before they both released their initial albums. And although the show never came about, Gold's main memory of that night revolves around how every so often, Mothersbaugh would disappear and then reappear wearing a completely different outfit without saying a word about it.

In 2008, Devo, or Devo 2.0, performed along with Chrissie Hynde and the Black Keys at a fundraiser for the Summit County Democratic Party and Barack Obama. In 2016 and 2017, Mark Mothersbaugh and Gerald Casale had talks and events at the Akron Art Museum, and Mothersbaugh has also had artwork exhibited at the museum, as well as performed there with his six-sided keyboard show.

Mark Mothersbaugh's six-sided keyboard, which he performed at the Cleveland Museum of Contemporary Art and the Akron Art Museum during his art exhibition in May 2016. *Courtesy of Calvin C. Rydbom.*

Mothersbaugh performing solo at MOCA after his six-sided keyboard performance. *Courtesy of Calvin C. Rydbom.*

Yet they are still often remembered as the funny band in yellow jumpsuits on MTV, the goofy band where the one guy wore the baby mask, an art rock joke band. Nothing could be further from the truth. Devo was born out of the turbulence of Vietnam and especially the May 4, 1970 Kent State shootings. They were angry with the state of their surroundings and as confrontational and punk as anyone recording at the time, just perhaps with a little art school leanings. As Butler, who knew many in the band before their first performance in 1973, said, "Devo was the most pissed-off band I ever saw." According to Butler, the *Akron Compilation* happened because Stiff Records execs were listening to bands around town and figured that there was enough for a compilation, if not anyone they wanted to sign to full-fledged deals.

Band Primer

There are so many Devo tracks worth tracking down. Two mentioned already, "Mongoloid" and "Satisfaction," are standouts on their initial album, *Q: Are We Not Men? A: We Are Devo!* "Satisfaction" is the quirkiest, most off-kilter cover of a known classic that became popular in its own right. "Mongoloid" is a go-to song for anyone who questions whether Devo is punk or not. "Gut Feeling," from the same album, is an often-overlooked gem; starting slow and pretty traditional, it just keeps picking up speed until it's just in a race to the finish at the end.

"Pink Pussycat" from their second album, *Duty Now for the Future*, is another good answer for those who don't see the band as punk; it's loud and fast with attitude. *Freedom of Choice* features "Whip It," which must be on everyone's "best of" list where Devo is concerned. But my favorite song on the album is "Just the Girl You Want," which is just exceptional in that it is quirky, repetitious and catchy at the same time. It may be my favorite song by Devo.

If it isn't, then my favorite song is "It's a Beautiful World," from *New Traditionalists.* By this point, I think Devo might have been getting more obvious in the messages they were trying to convey, as well as getting a tad more traditional in their music.

Hammer Damage

The one thing that should be made clear from the start is that Hammer Damage was in no way an extension of the Rubber City Rebels. Yes, Mike Hammer and Donny Damage were both in the Rebels, but Hammer Damage was clearly their own entity. Both Hammer and Damage say there was no intention of breaking away while in the Rebels.

The story about how the Rubber City Rebels got together in Akron and moved to Los Angeles, along with the problem with Sire Records, was covered thoroughly in the section on the Rubber City Rebels, although all the members remembered it a bit differently. Hammer and Damage had gone back to Akron for a while, while Bent and Clic were working on the deal with Sire. Hammer remembered getting a call that Sire wanted him and Damage to join the other guys in L.A. for a showcase with a bunch of industry heavyweights. And after the show, where they were expected to be great, Sire would sign them as the first act to be handled by their London office. Hammer, who was nineteen, was overwhelmed thinking that he was about to be flown to London to make music with his band. Never happened.

Hammer and Damage flew out to L.A. for a show, and none of the industry people showed up. So, the entire band flew back to Ohio and played a show; somewhere along the line, they split from Sire. The band's manager, Michael O'Brien, wanted the whole band to relocate to L.A. and get another deal.

Hammer admitted that he never really did like L.A., and right at that time, Damage's wife became pregnant and his father became very ill. So, they suggested Clic and Bent go back and take care of the legal issues, as they were legally bound to Sire for eighteen months, and get another record deal—as soon as they did, they would come back out, the idea being that they had learned all the ups and down of the process the first time, so it was going to be a lot easier. But that never happened.

What did happen is after a time Damage suggested that maybe they should pick up a few other guys and go out playing some Rebels tunes so they don't get stale. They had recently seen the band Yankee with Scott Winkler, former bass player with King Cobra. The guitarist in the band was, of course, George Cabaniss. According to Hammer, he was talking with Cabaniss, whom he said he barely knew, and was explaining that he and Damage were on hold but were probably going back to L.A. soon but wanted to find a bassist to do some shows with in the meantime. Cabaniss told him he needed to play with Demon and Dash Rip Rock, to which Hammer asked, "Who is that?" Cabaniss explained to him that he meant himself

Hammer Damage at Stonehedge Place in 1978. Now mostly a bowling alley, at the time the bar booked live acts on a regular basis. *Courtesy of the "Akron Sound" Museum.*

and Winkler. So, Hammer went to Damage and told him that Cabaniss and Winkler said they'd learn some Rebels songs and they could call themselves "Hammer Damage."

Hammer and Damage, of course, never went back to Los Angeles, and Clic and Bent hired a few local guys to replace them, although the foursome has reunited many times over the years. Hammer said that he learned a lot from the Rebels, mostly about always being very tight. Always practice until you can't practice anymore and be just as maniacal about being tight on stage. With that in mind, Hammer said that they started developing the idea of having one song's exit being the next song's intro. So, as he said, "Instead of being song, song, song we were 3 songs, 4 songs, 2 songs." The more they planned for that to happen, the more natural it became for the songs to just blend together. Hammer recalled the crowd just loving it: "It was such a crowd pleaser because they'd be *boom, boom, boom*, they are already in the next song." He specifically pointed out their song that was the "Munsters Theme"/"Gloria"/"Riders on the Storm." Their songs weren't really punk, but they gave off a punk edge, according to Hammer.

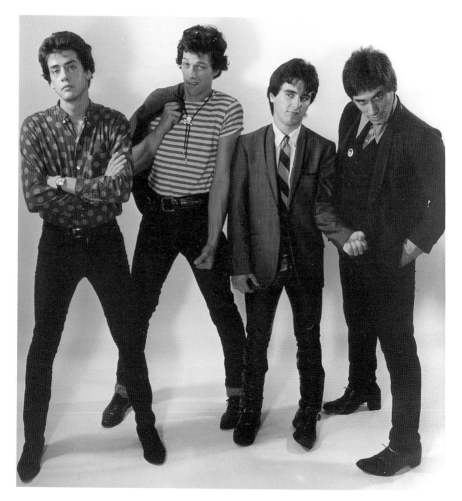

A promotional image of Hammer Damage. *Courtesy of the "Akron Sound" Museum.*

Some of their covers, though, and there weren't many, were made for self-preservation. Hammer remembered the spiky-haired punk kids who were following them coming to JB's when the bikers were there to see the Numbers Band (15-60-75) and sometimes a bit of trouble broke out. So, they added Steppenwolf's "Born to Be Wild" to their set list with the idea that the bikers would think that maybe these guys are all right. It became one of their more popular tunes. But like all their songs, there was a "Hammer Damage filter" that all the songs were run through.

The band developed quite a following, not just in Akron but on the coasts as well. They opened for the B-52s, Public Image Ltd., the Dead Boys and

others in Cleveland, New York and Los Angeles. Of course, for Akron and Kent music fans, it was all about seeing them on Thursday nights at JB's in Kent and at the Bank on the weekends. They were staples of the Akron music scene when they were in town. According to Hammer, they never got crowds anywhere else like they did in Akron, even up in Cleveland.

Hammer talked about having played with great musicians over the years, but he never played with a group whose chemistry was so good, a band whose camaraderie was as good, as Hammer Damage. The guys simply fed off one another's playing, ideas and personality in a way he hadn't experienced before or since. When asked, neither Hammer nor Damage say so directly, but when they speak of the band, they speak of them, Winkler and Cabaniss—even though in the later years, talented musicians such as Bob Basone, Ray Wolf, Kal Mullens, Dave Ihmels, Alison Berger and Ig Morningstar all passed through the band. And Hammer and Damage do speak highly about everyone who ever passed through the band. They both will tell you what a great guitarist Ihmels is, technically the equal to Cabaniss, according to Hammer, although there simply wasn't the same connection on stage as with Cabaniss. Morningstar and Basone's skills are well known in the area, and they both feel that Wolf did a fine job holding down the bass spot. Mullens's time in the band was so significant that the original four still get together once in a while to play some shows, forming a quintet, with Mullens as part of the mix. In fact, Hammer will tell you that when he thinks of Hammer Damage now, he thinks of the five of them and that he couldn't imagine playing without Mullens. But when they talk about the past band, the amazing chemistry, how they were all on the same page, they talk about themselves, Cabaniss and Winkler.

When it was those four, they were one of the best bands in the country, according to Unit 5 and Tin Huey drummer Bob Ethington. And he was hardly the only person who felt that way. The rest of the band had no hard feeling when Cabaniss was offered, and took, a spot in the Dead Boys. How can you be mad when your friend gets that kind of opportunity, Hammer noted.

Hammer felt that Mullens fit in much more quickly because he had experience playing in his own originals band, Teacher's Pet; for Hammer, playing in a band and an originals band were two different things. But he felt that Mullens fit in from the start perhaps in a way nobody else did. Damage loved the idea of Mullens joining the band since he could put his guitar down and focus on being a front man.

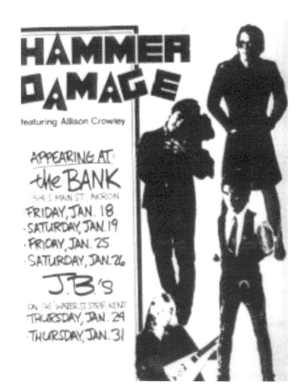

Left: A flier for some upcoming Hammer Damage shows. The "Featuring Allison Crowley" note was because she was a guitarist from New York City and therefore "special." *Courtesy of Dick Robbins.*

Below: From 2011, the original four members along with Kal Mullens playing at Jilly's Music Room. *Courtesy of the "Akron Sound" Museum.*

Today, when they do the occasional gig (but don't call it a reunion, especially around Damage), it's the original four plus Mullens. In their minds, the band never really broke up. Sure, they stopped playing out, but that was more because spouses, careers and kids started taking precedent. That's one of the reasons they don't like calling any of their gigs that happen every few years "reunions."

Most of them still play. Mullens and Cabaniss have a band called the Bad Dudes that will release a CD soon. Damage has become much more involved in straight-ahead blues bands the last four years, and Hammer is down in Atlanta playing in some high-energy country rock bands, including one with some folks who were involved with the Georgia Satellites, who went to number two in 1986 with "Keep Your Hands to Yourself."

I wouldn't at all be surprised to see them playing out again someday soon, especially since they never broke up.

Band Primer

Hammer Damage put very few songs on record, but you can find several either on bootleg or video recordings if you look. Hammer felt that they never recorded well, as the energy they had as a live unit just didn't transmit to the studio. More likely, as with a lot of high-energy bands, they tried to be too precise or perfect in the studio and lost that live dynamic they had in the process. According to Hammer, there are actually a lot of tapes they did at After Dark Studios in Parma, Ohio, out there somewhere, but they simply aren't worthy of being released, in his mind, so they never have.

The only thing that has been released was the single "Automatic Lips." Cabaniss's solo about a minute and a half into "Laugh" is just blistering, especially for a punk song. The attitude, the tone of Damage's vocals, is so punk, but the band seems to be hard rockers. "Automatic Lips" is a little more melodic, but it has no less of a punk and hard rock mesh. The single is still available, and it's a must-have for those fans of early 1980s punk and hard rock.

"Noise Pollution" can be found on the Clone Records release *Bowling Balls from Hell*. It isn't the same kind of song as the other two released tracks, but it gives you an idea of what the band was about.

Some songs are only available as a bootleg, like "4-4 Time," written by Cabaniss as a riff-reliant rocker. It's a great song that only a lead guitarist would write. Stiv Bators covered it later, and both versions are worth listening to.

"Mercenary Love" by Winkler is a lot more high-energy power pop that starts out with an amazing intro by Hammer. "Public Guy" by Damage is a lot harder to find but nonetheless enjoyable.

There is a CD called the *Official Bootleg CD* that includes a lot of the demos they cut in 1979, and it's floating around out there. And a DVD was made from a 2005 show at Akron's Lime Spider. Their recorded history is certainly out there; it just takes some work to find.

UNIT 5

Unit 5 lead singer Tracey Thomas wanted to be Marie Osmond at an early age—not the late 1970s pop star, mind you, but the early 1970s "Paper Roses" country singer. And while I recently saw her with a new band doing a number of classic country tunes as well as originals, it really didn't work out that way.

Unit 5 was a fun, high-energy band from the second wave of the "Akron Sound" that mixed punk and new wave sensibilities into a great package. Having a thin young blonde as the lead singer naturally invited comparisons to Blondie, whether it was intended or not (it wasn't), something that Thomas is both a little flattered but really more annoyed by. Unlike some of the other acts from the era, though, their time together as a band was fairly short-lived. While some of their contemporaries also only lasted four years or so, unlike most, they navigated through those years without a single lineup change.

Thomas knew that she wanted to sing at an early age. It wasn't until a friend asked to manage her after hearing her sing in a car at the age of sixteen that she seriously decided to make a go of it. She found herself singing at a high school party, where a few guys came up to her and asked if she wanted to sing in their band. One of the members of the band, and now a lifelong friend of Thomas's, was Dave Ashley, who later was in an early incarnation of Jane Aire and the Belvederes and the early '80s Bizarros, among other bands.

Even though she was in a few groups early on, she considers Unit 5 to be her first real band. They didn't start out as Unit 5 though. Early on, they were known as the Vapors and performed numerous times under that name, until another band—this one an English band that had scored a minor U.S. hit with "Turning Japanese"—sent them a cease and desist order. Thomas

Tracey Thomas performing with Unit 5.
Courtesy of Jimi Imij.

told me they also considered the name Special K, which she laughs at now. Thankfully, they decided on Unit 5.

The band itself included Mark Johnson on lead guitar, Bob Ethington on drums, Paul Teagle on keyboards and Mark Jendrisak on bass along with Thomas. Ethington, who was admittedly a jazz snob in the years leading up to Unit 5, met Thomas when they were both working at Record Theater in West Akron. At first, Thomas pitched a country band to Ethington, but that was a bit too much of a stretch for the jazz drummer, who had only recently started to get into some of the punk acts such as the Stranglers.

Later, when Thomas came back with the idea of a more new music band, bringing along another musician (Jendrisak) she had been playing with in another band that really didn't go anywhere, Ethington was in. He remembered taking a fair amount of grief from the friends whose musical taste he had criticized over the years, admittedly deservedly so. Teagle was a friend of Jendrisak's, and his keyboards fit immediately into what they were doing.

They had considerable trouble finding a guitar player, though. Ethington remembered auditioning a lot of guys who could play but just weren't the right fit. Jendrisak, Ethington and Thomas had been writing together for a while and already had a few songs, and it seemed every guitar player just didn't fit their sound—one that was really fun new wave/punk that you could dance to. Ethington remembered a lot of heavy metal guitarists who seemed more interested in them becoming their band. The band's sounds, even in those early days, did not rely on loud guitars and solos. In fact, they shied away from them.

Meanwhile, their friend Johnson had been learning guitar, but he was still very much the novice, and nobody really thought of him for the slot in the band. Still, he had been playing the guitar parts at their practices to help them out as they worked through the songs. Eventually, it became obvious to everyone in the room that while Johnson wasn't a skilled guitarist yet,

he was a great fit in the band personality-wise. More than any of the more accomplished players they had auditioned, Johnson made sense.

They easily settled into a complete collective effort. Johnson really brought a pop sensibility to the group. Ethington and, to some extent, Jendrisak were a bit more off-kilter—perhaps even more so later when they started listening to the Talking Heads and Brian Eno. But as a band, the five fit.

They found themselves opening for the Bizarros, who had already developed a large following by that point. Thomas felt that the band owed a lot to Nick Nicholis, lead singer of the Bizarros, as he took them under his wing, even producing their only album on his label.

Thomas was also very appreciative of Debbie Smith and Sue Schmidt from Chi-Pig. "I was the new girl on the block and pretty young, and sexism was alive and well back then. There weren't a lot of groups fronted by women." According to Thomas, the women from Chi-Pig were amazing in the way they made her feel welcome to the club.

It was very much a family, according to Thomas, so much so that the bands from that era often got together and played softball on Sundays—a memory mentioned by a few of the era's musicians.

Unit 5 quickly rose to the top in popularity, as they were deceptively unique. As Ethington explained, most groups are top heavy, with the lead

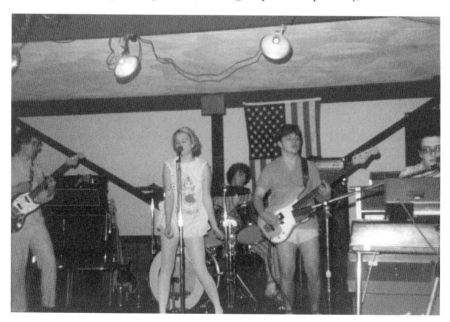

Unit 5 at the Robin Hood. *Courtesy of Jimi Imij.*

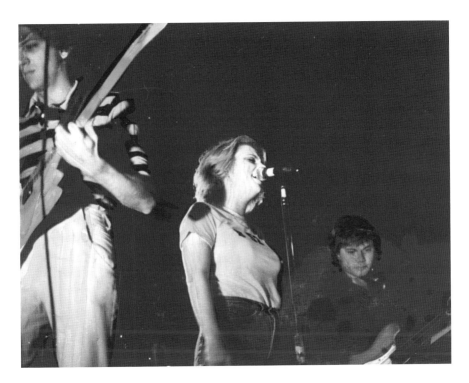

Unit 5 onstage. *Courtesy of Jimi Imij.*

guitarist dominating, but in Unit 5, the rhythm section did. Jendrisak and Ethington were always extremely busy, as well as being very rhythmic. It set the band apart in their sound.

As their popularity rose, they went from opener to headliner. They frequently played the Bank, swapping the top spot with Chi-Pig and Hammer Damage. They also found time to do some side projects. The Grey Bunnies, including most of the band, even managed to have a single released on Clone Records.

They released a Unit 5 single for Clone in 1980 and then the album *Scared of the Dark* in 1981 on the same label, which in many ways led to the demise of the band. Thomas was very disappointed in the album, feeling that it in no way captured the band's live energy.

Ethington's memory is that the raw tracks he had kept from the sessions sounded fantastic. But somewhere along the line, perhaps in the mastering, a much more lackluster album emerged. "I still remember to this day," Ethington told me. "We got the album, put the needle down and after about three tracks, we were all like, 'What happened? This sounds like crap.'" It sounded compressed with all midrange to him. In retrospect, he thinks

A promotional image of Unit 5. *Courtesy of Tracey Thomas.*

they might have even had something to do with the sound, as they told the engineer to do this or that with the keyboards and he did—perhaps all the time thinking, according to Ethington, that they shouldn't be doing this, but he said nothing and did it anyway.

Thomas thinks that the fact no major label seemed interested in signing them after their New York showcases had something to do with it as well. Ethington also added that they were playing almost every night and had settled into somewhat of a rut. They played the same songs every night, and the entire situation was getting stale. A segment of the band felt that they should commit to the band full time, working on adding a bunch of new songs to their sets, retiring some old stuff and moving to New York to really make a go of it. Unfortunately, they couldn't come to an agreement on this, and because they didn't want to be stagnant, they decided to throw in the towel.

They had recorded six new songs by that point, though, which have never seen the light of day. According to Ethington, they are certainly more mature songs, as they weren't as concerned with being fast and danceable, even though you could dance to them if you chose. So, the band was seeming to mature. Today, some thirty-five years later, they all feel that they gave up too soon and that the band had more they could have accomplished. Ethington told me in hindsight that they were too abrupt, thinking the band needed to be all or nothing.

They didn't quite end when Unit 5 ended though. Jendrisak and Ethington formed another band, or at least tried to, as it never quite happened when they really couldn't find other bandmates with whom they gelled. But they had been writing songs, and they had the six left from Unit 5, so they found themselves falling back together with a new band that was essentially the same as their old band. Johnson had joined the navy in the interim, but other than that, the new group was Unit 5. They decided to call their new group Gone to Egypt. Ethington told me—apologizing if he sounded too self-

Thomas's show celebrating her fortieth anniversary as a performer; Jendrisak and Ethington also performed. *Courtesy of Calvin C. Rydbom.*

important by saying so—that it was the great lost band of the era, in large part because their songs were better, more mature, as they had learned a lot during Unit 5 about what a song didn't need to be as much as did need to be.

But they managed to play just three shows at Mother's Junction in Kent. Then Thomas became pregnant and felt as a mother she didn't want to spend all her nights in a club. Ethington's wife also became pregnant after that. So, Unit 5 hung it up for more than a decade.

In the mid-1990s, the band did a reunion show, and the bandmates worked with one another quite a bit over the years. It wasn't all that long ago that I was at an anniversary show celebrating Thomas's fortieth year in the business where a few of the guys showed up and performed.

Thomas took a few years off but started recording solo albums a few years after Gone to Egypt finished. She has recorded a number of them over the years, moving from rock to jazz with ease, and she recently started fronting a country group called the Crowders.

Ethington also took quite a few years off to raise a family but soon found himself out playing more than he ever did other than at Unit 5's peak. As well as being the drummer of Half Cleveland, along with Harvey Gold and Chris Butler of Tin Huey, he has several other projects and has recently released a solo album.

Unit 5 stands apart from other groups within the top tier of the "Akron Sound" and sometimes doesn't get the respect they deserve, perhaps

because they didn't have the anger and aggression on stage that most of the other bands did. They were much more about having fun and dancing, even if their music was also different and a bit off-kilter from popular music at the time. Unique and different but fun to dance to is not a bad thing to be.

Band Primer

Unlike many of its fellow bands in the "Akron Sound" era, Unit 5's recording history is pretty brief, but they got thirteen songs recorded; at least one of their contemporaries in the top tier didn't manage that. The band's entire output was a single in 1980, the LP *Scared of the Dark* and a 1981 Akron bands compilation called *Bowling Balls from Hell II*.

"Graceful and Lady Like" showed up on all three releases. It's a cool introduction to the band, as it features an instrumental intro of forty seconds before Thomas begins to sing. You can imagine the dance floor throbbing with college age and somewhat older kids before Thomas stepped up to the microphone. The bass is upfront in the song, arguably the primary instrument in the song. It's a great tune with some odd sound effects and a long instrumental break but some great Thomas vocals. She and Johnson are credited as the songwriters, which makes it obvious why she seems to so easily voice the lyrics "I can hold my own."

"Go Ahead and Kiss Her," a Johnson-penned tune, appeared on both *Scared of the Dark* and *Bowling Balls from Hell II*. It's a fantastic example of how much fun the band could be. I have to agree with the band, though, that it was such an incredible live piece, especially the way Thomas held the stage. It's a simple song, really, about making eye contact with a good-looking girl on the dance floor. "Go ahead and kiss her, go ahead and tell her your name. Go ahead and kiss her, go ahead and make your play."

"Like Lovers Feel" starts with a great bit of keyboard and proceeds into a nice drumbeat. Thomas's vocals are stronger and less playful than her usual during this period. It's a great song, highly danceable and perhaps more rock than their usual sound.

"New Leather Jacket" appeared only on *Bowling Balls from Hell II*. And while it is credited to Teagle, Jendrisak and Ethington, it is really a Teagle song that Ethington and Jendrisak made some additions to, as Ethington noted. It may be an example of where the band was heading musically, as it wasn't the high-energy dance songs the previous two songs were.

Also, Teagle taking lead vocals as opposed to Thomas really changes the way the song is delivered. Ethington thinks it's the best song they ever recorded.

Regardless of whether you like the more fast-paced dance songs or something like "New Leather Jacket," it's hard to miss the potential that Unit 5 never got the chance to fulfill.

CHI-PIG

Not to take any credit away from Chi-Pig and their time together as a band, but it's difficult to tell the story of the band without first mentioning the Poor Girls. Debbie Smith first moved to the area in 1964. She, Pam Johnson and Susan Schmidt were all taking lessons with music teacher Joe Ciriello at Litchfield Junior High School when he suggested they form a band, along with drummer Mary Esta Kerr, who was an accomplished musician—she even had her picture taken with Gene Krupa for the newspaper before the band was formed.

According to Schmidt, a lot of guys saw them as a curiosity, but they were taken seriously by those same guys because they could play. One of the first gigs they played was at the Outer Limits in Brimfield in about 1966 with Joe Walsh's the Measles. According to Schmidt, Walsh told them they were going to be really good in six months, which seemed like an eternity to her at that point.

The band practiced at Pam Johnson's house and soon were playing out regularly in the late 1960s. They played at a lot of teen clubs throughout the area, sometimes every weekend. During those years, there were countless teen clubs all throughout Northeast Ohio. They also found themselves opening for Steppenwolf and Cream at the Akron Civic Theater. Unlike Chi-Pig, though, at this point Schmidt and Smith and the Poor Girls were certainly a cover band, albeit a very eclectic one. As with all the Akron bands of the era, there was a fair amount of crossing paths. In the Poor Girls case, it was Smith's close friend Chrissie Hynde helping sew the outfits they wore at one of the Akron Civic Theater Shows.

The band split up after graduation when Schmidt decided to attend college at the Berklee College of Music in Boston. Smith got an offer, which she accepted, to become the house bassist at Electric Ladyland in New York City. Smith also once stepped in for John Paul Jones during a Led Zeppelin

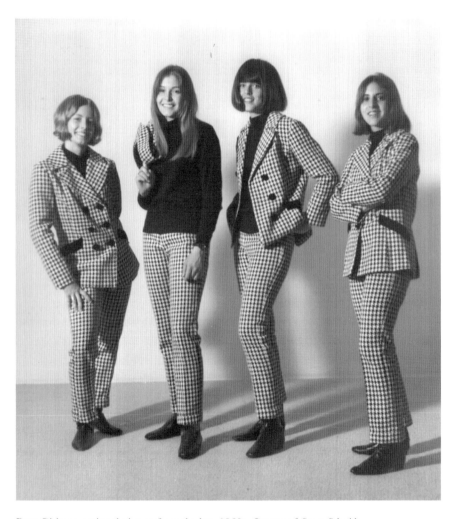

Poor Girl promotional picture from the late 1960s. *Courtesy of Susan Schmidt.*

date when his father passed away and he had to get back to England quickly. The high school girls were progressing quickly in their careers.

For the next few years, Smith and Schmidt played together off and on in a number of bands, more than Schmidt says she can recall, including even a few wedding bands that she referred to as lounge acts. Of course, there was also Cinderella's Revenge and Friction with Peter Laughner or Rocket from the Tombs and Pere Ubu. One Schmidt does remember was the Paris Dream Band. That band had her, Smith, Scott Krauss (who later was the longtime drummer of Pere Ubu) and Cindy Black, who played in some

other local bands with Krauss and Laughner. They never made it outside of Schmidt's basement, though, as Black played a Mellotron keyboard, which sounded great but was difficult to move.

Chi-Pig became a band in 1977 when Schmidt and Smith met Richard Roberts, who had been playing in a jazz-oriented trio with future Devo drummer Alan Meyers and future Tin Huey saxophonist Ralph Carney. Whether Meyers introduced them or they met at a Devo show at the Crypt isn't that important really. What was important, according to Smith, was the progression that they had over the decade. They really gelled as they played more and more with Roberts. Schmidt and Smith might have gotten there somehow otherwise, but as a trio, the musical conversation just flowed.

The band took its name from a local barbecue restaurant that sold both chicken and pork. They started fast, as one of their first live performances was at JB's opening for Tin Huey the night Jerry Wexler from Warner Bros. came to scout them. By 1978, they were one of the bands to appear on the *Akron Compilation* from Stiff Records, and they released as a single "Bountiful Living" with "Ring Around the Collar" as the B-side. Mark Mothersbaugh of Devo lent assistance with lyrics on the single.

They became known for their colorful outfits. Schmidt remembered being in Miami to record at Criteria and finding what she, and others, described as Ricky Ricardo shirts. There were also a lot of colorful outfits dug out from Goodwill and other like-minded stores.

An interesting side story to the Chi-Pig tale was their relationship with Klaus Nomi, who was a New York City new wave artist at its finest. Chi-Pig opened for Nomi at Club Hurrah! in NYC, and a conversation occurred between the band and Nomi and his manager about playing outside New York City. With their help, Nomi got booked at the Bank in Akron; as Schmidt remembered, "The usual clientele there was totally ready for him." Nomi made at least one more trip to Akron, but that first visit made the front page of the *Akron Beacon Journal*'s Sunday entertainment magazine. Their first single appeared in the soundtrack of *The Nomi Song*, a documentary on him released in 2004.

In 1979, they met Bruce Hensal, who was an engineer at Criteria Studios in Miami. The owners were allowing the engineers who worked there to bring in artists who interested them when the studio wasn't booked, usually early in the morning or late at night. The band stayed in Miami for six weeks, recording when they could, staying in an inexpensive beach hotel and booking as many shows as they could.

Performing at Akron's Soap Box Derby. *Courtesy of Andrew Cahan.*

They recorded an album's worth of material on a 16-track, but it never got mixed, although one of the assistant engineers gave Schmidt a rough mix she held on to for years. Smith remembered listening to it years later and thinking that it wasn't bad at all. And they wanted to get it released, so the recording would be more permanent and not transitory, as the tapes usually were. In the early 2000s, technology allowed them to do so and then release it without being signed to a label. When they eventually got the album, called *Miami*, released in 2004, it was extremely well received by critics.

During the first few years of the 1980s, Chi-Pig was one of the handful of bands that headlined the Bank, Akron's second iconic punk/new wave bar, but a major record deal never materialized. The band got offered the opening spot on an East Coast tour with the English band the Stranglers. At the time, Roberts either couldn't go or wasn't interested, and Schmidt and Smith decided to find another drummer, which never really happened, even though Smith remembered auditioning several people. "He was more than a drummer," according to Smith. "It was the interaction and subtle conversation between us we mistakenly thought we could replace."

In 2005, the trio reunited for the benefit to raise funds for medical bills that Mark Price of Tin Huey and Bushflow Studios had accumulated. Unfortunately, Smith had injured her hand and was concerned that she

Smith performing with Chi-Pig in the early 1980s. *Courtesy of Jimi Imij.*

wouldn't be able to perform. The bassist they recruited to play with them was Abby Quick, the teenage daughter of their guitarist from the Poor Girls. Smith was able to play, but Quick joined them on stage anyway. They did a few other shows after that, but as Smith said, "I didn't really want to be a Chi-Pig tribute band." The band decided to end it on a high note.

So with that, Chi-Pig was over as a band. Smith played in Half Cleveland with Harvey Gold (Tin Huey), Chris Butler (Numbers Band/Tin Huey/the Waitresses) and Bob Ethington (Unit 5/Tin Huey). Schmidt obtained her PhD and has written extensively on music and music theory, although they had both started down those paths before their reunion shows. Chi-Pig will always be remembered as skilled and smart songwriters who often used humor while frequently addressing the world from a more feminine perspective than their fellow musicians in Akron.

Band Primer

The recorded history of Chi-Pig is small, but that doesn't mean there aren't a couple of songs that need to be heard if you consider yourself a fan of the "Akron Sound."

From their first single, "Ring Around the Collar" just jumps off that initial line. Fast, sharp and smart, it's almost a straight-ahead rocker. But it has edge and is a precursor for what would come.

"Apu Apu (Help Me)" is a wonderfully off-kilter song from *Akron Compilation*. The music itself is a tad more offbeat than the two songs from their first single and really foreshadows what would be recorded for the *Miami* album. While "Ring Around the Collar" had a sense of normalcy, this one did not, albeit in a very cool way. Even though the songs from *Miami* didn't get released until twenty-five years later, they are a record of a band nailing it in 1979. "Waves of Disgust" is just fun, as the fast-paced song describes these

same waves of disgust cascading over the singer. "Dismissal Dismissal (No Cash, No Sale)," from the same sessions, also manages to be fun, almost tongue-in-cheek, while having very smart lyrics.

THE WAITRESSES

The Waitresses had a very twisting and turning history, even for an Akron band. But their twists and turns were very unique when compared to their fellow bands. Chris Butler was the only person on their first and last recording, mostly since they started as a pretend band. This, of course, also means that he was the only member of the band on every cut—unless you count some demo recordings done without him at the end that were never released. If so, then nobody was on every cut, and the band at its start and on its final days didn't have any of the same members—not uncommon in these days of bands touring the oldies circuit twenty-five years after their handful of hits but quite unusual for groups that barely lasted more than five years.

The Waitresses started in large part because of Butler's frustration with lack of opportunity to really be creative and do what he wanted, which was mostly to write his own songs. Butler was playing bass at the time for the Numbers Band (15-60-75) and was playing with them a few nights per week at JB's in Kent—not just playing but packing them in. They were, and are still, a great band. But they are a project defined by Robert Kidney and, to a lesser extent, Jack Kidney and Terry Hynde. The young kid on bass wasn't having much opportunity to stretch himself in the way he wanted.

One afternoon, while having lunch with his friend Liam Sternberg, they came up with some ideas about how they could allow themselves a chance to work on their own projects. Sternberg, who would go on to produce the *Akron Compilation* for Stiff Records and have success as a songwriter, was also looking for a project to focus on. They had both been writing songs but had full-time jobs, and Butler was already in a band. Starting another band wasn't an option.

At some point, one of them (just who it was is lost to time) suggested that they make up some imaginary bands. According to Butler, Sternberg was very excited by the idea. He told Butler they could tell big whopping lies and even give the bands names. Butler, who was publishing a small fanzine in Kent called *Blank*, figured he could use it to promote their fake bands. "There was this amazing waitress at the place we were at with a big beehive

The first release, when the band was still just Chris Butler and pretend musicians. *Courtesy of Chris Butler.*

hairdo." Plus he figured it was an inside joke as well because of all the actors, actresses and musicians he knew who were waiting tables. So his imaginary band became the Waitresses. Sternberg's imaginary band wound up being another well-known Akron product, Jane Aire and the Belvederes.

Butler and Sternberg began to play on each other's projects, recording at both Bushflow Studios, owned by Tin Huey member Marc Price, and Rick Dailey's studio, which was also in Akron. Butler released *Short Stack* in 1977, which had "Slide" on the A-side and "Clones" on the B-Side. Both sides also wound up appearing on the *Akron Compilation*.

Butler's side work began to take up more and more time, to the point that he missed practice, something you didn't do if you were a member of Kidney's Numbers Band. Butler remembered Kidney telling him, "I can't give you what you want, kid." And with that, Butler was no longer a member of Kidney's band.

He joined Tin Huey not too long after that, even though he told himself at the time that he never wanted to be in another band. But he kept working on material for his imaginary band, both writing and recording. He had written "I Know What Boys Like" and recorded it on a 4-track machine owned by Chi-Pig's Sue Schmidt, but he felt it didn't work. He knew he needed a female singer for the song, but everyone he knew seemed to be busy. So he went to Walter's Café in Kent, stood on a chair and yelled out that he needed a female singer to record a demo of a song he had written and asked if anyone was game. From the back of a room, he heard Patty Donahue yell out. They knew each other somewhat, as Donahue had been dating the drummer from the Numbers Band (15-60-75), and she was willing to give it a try. "We wound up rehearsing at her house," according to Butler. "Then we went over to Rick Dailey's studio where I had recorded the backing tracks. She did her thing, and it was great."

Oddly enough, *Village Voice* music Robert Christgau mentioned the Waitresses—and the fact they were an imaginary band—in his article on the local scene early in the spring of 1978. National recognition before your band is formed rarely happens.

Butler also clearly remembered his bandmates in Tin Huey making fun of him a bit for "lowering" himself to playing pop music, as they were very much art rock, albeit very off-kilter art rock. What's odd is a few them played on the initial recordings, but then it was pretty standard for them to play on each other's side projects. Not long after those early Waitresses recordings, with only future members Donahue and Butler, Warner Bros. decided that it didn't need a second album from the Tin Hueys, and the group more or less drifted apart. Some stayed in Akron, some headed up to Woodstock and Butler headed for New York City. Tin Huey was very popular there, which he felt he could use to his advantage. He also, once again, decided that he was done with being in a band.

So, he had his buyout money from Warner Bros. and a single he had recorded with Donahue—a single that a lot of people in the business were telling him was a hit, a sure-fire hit. Butler took his single down to a very popular New York City club and asked the DJ to play it, and the crowd loved it, so much that the excitement the single generated reached some music executives almost immediately. Butler found himself in a meeting the very next morning. Of course, when they asked him where his band was, as they needed a B-side for the single, Butler was a bit stumped but bluffed and told them the band was back in Ohio.

He called Donahue and told her that he had a record deal and asked her to come to New York City and see if they could actually be a band. Butler had to front her some money to get her there, so he had his singer but he still didn't have a real band. So, he recruited former bandmate Ralph Carney along with Dave Hofstra and some other musicians to record another song he had written called "No Guilt."

He and Donahue had a single out and a small record deal and finally decided that maybe they could be a real band. Carney wasn't interested in being a Waitress full time but introduced them to Mars Williams. Dan Klayman was around and from Akron, and he and Butler somewhat knew each other. Butler knew Bill Ficca from when he was the drummer for Television, as Tin Huey had opened for them in New York City during Television's final six shows. Butler swears to the story that one of his friends saw Tracy Wormworth walking down the street with her gig bag, after Hofstra decided he wasn't interested, and told her that his friend's band needed a bass player and that's how they found her.

Island Records signed them and placed them on one of its other divisions in Antilles Records. This somehow found them on an affiliate of Antilles called ZE Records. This, of course, meant that both of their albums and

The second real member of the band, Patty Donahue. *Courtesy of Chris Butler*.

their one EP got released on Polydor. It was a mess and, as Butler said, some bad deals.

But while still at ZE and before their first album came out, the band got a call telling them that ZE had decided to release a Christmas album. Butler wasn't too thrilled with the idea, but the band headed over to Electric Ladyland to record "Christmas Wrapping," which Butler was still writing in the cab on the way to record it. They did it, but he considered it a throwaway and promptly forgot about it. During the time when the band was moving over from ZE to Polydor, he completely forgot to mention this throwaway song he had recorded for the ZE Christmas album. This meant that when Polydor acquired the band from ZE, "Christmas Wrapping" wasn't part of the deal. Polydor did eventually acquire it, though.

Butler remembered being completely taken by surprise when someone told him that he was all over the radio. He assumed "I Know What Boys Like" had finally broken through from college radio to mainstream radio, but he was shocked when his girlfriend told him that it was a Christmas song.

Butler and Donahue hanging out with Rick Moranis and Dave Thomas. *Courtesy of Chris Butler.*

Things were going fairly well for the band. They had a few songs that weren't quite hits, but they were doing well enough that people expected them to break through fairly soon.

They had been on a three-week string of gigs without a single night off, ending in Washington, D.C., when their next break, for good or bad, happened. They were planning on heading home for a rest, but that wasn't to be. Just as Butler was about to check out of his hotel, he got a call from *Saturday Night Live* writer Ann Beats, who was at the home of John Belushi's recent widow, Judy, when she called. They had liked the song "No Guilt" and wanted them to be a musical guest on her new television show *Square Pegs*.

At least, that was what Butler and Beats agreed on over the phone that night. Butler remembered her telling him that they didn't need to bring their instruments, as they would be just props anyway, and everything would be paid for. So they sent their instruments back to New York and headed over for a noon flight at Dulles, where tickets were waiting for them but not paid for. A call to L.A. gave them the explanation that the *Square Pegs* people weren't sure they were really coming so they didn't pay for the tickets but they'd get reimbursed when they got out there.

Promotional image of the band. *Courtesy of Chris Butler.*

Beats was waiting for them when they landed, and she was shocked that they didn't have their instruments. It seemed that while the band was on an airplane from D.C. to L.A., the musical guest spot had turned into Butler writing the theme song in the next few hours and recording it shortly after that. Butler actually managed to whip together the theme song in one night and knock it off at Motown West the next morning. And, of course, they appeared on one of the episodes. Butler spoke well of Beats, but it wasn't altogether a great experience for him or the band in his mind.

After the second album came out, which didn't do nearly as well as the first album or the EP, the band went off to England to record with Butler's dream producer, Hugh Padgham. Butler believes in hindsight that he didn't have enough songs, and most of the band was partying way too hard; they should have put it off for six months. But while there, he felt that Donahue wasn't up to singing one of his newer songs, so he told her that Wormworth was going to sing it, causing Donahue to explode and quit the band. Of course, the record company was none too happy about this, as it had albums to sell and no band to promote them. So the label convinced Donahue, through some economic incentives, to return to record a video for one of the singles

GUEST CHECK

TABLE SERVER 182066 GUESTS

CHFD CB
KMO
FF
SOUP
C

**THE
WAITRESSES**

TAX

Promotional material for the
Waitresses. *Courtesy of Chris Butler.*

from the new album so it could at least have something with which to promote the band's third release, *Bruiseology.*

Wanting to keep the band together, Butler brought in Holly and the Italians lead singer Holly Beth Vincent to replace Donahue. He was excited with the prospect, as he felt Vincent had much better range and she also wrote, which would take the burden completely off him to provide material. Unfortunately, after a few gigs, Vincent failed to show for a show at Columbia University, and the band found themselves without a lead singer again. For Butler, that was it. He was done, and he felt that the Waitresses were just as done.

Donahue felt differently, though. She offered members of the band a salary arrangement to essentially be her backing band, with her continuing to record using the Waitresses name, which infuriated Butler. "She fell in with some bad people, bad advisers," according to Butler. "She went Hollywood on me, and I walked out of our last meeting." Donahue hired another songwriter and supposedly demo tapes exist, but Polydor wanted nothing to do with the band after hearing the tapes. Butler didn't speak with Donahue and avoided her for years, until he heard that she was ill. He called her in the fall of 1996, a few months before she passed away from lung cancer. The first thing she said to him, according to Butler, was, "I'm so sorry." After that, Butler felt, "I figured OK. I knew she was terminal but I talked with her and made plans about playing together but she died not long after that." The plan they talked about was a charity show during Christmas for the Lung Cancer Society, but Donahue died on December 9.

Butler has played around with the idea of doing more Waitresses shows, even a small tour, with rotating lead singers and shows done only for charity, but it never came together. He and others members of the band had no interest in finding themselves on the '80s oldies circuit.

The band members have done well for themselves after the Waitresses folded. Butler actually left music for a few years after everything fell apart with the band. He worked as a writer and editor for a number of technical

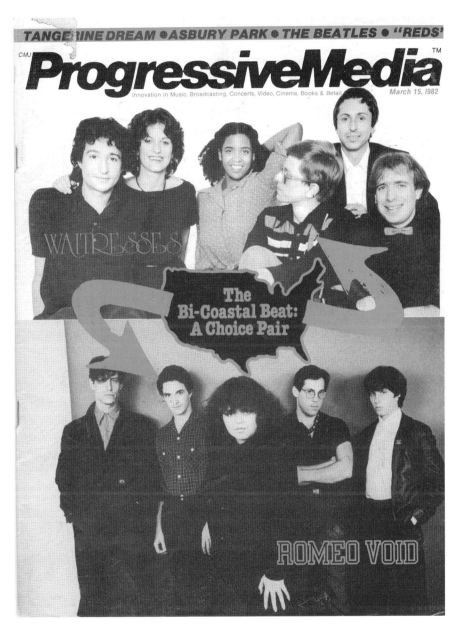

The band on the cover of *Progressive Media* magazine. *Courtesy of Chris Butler.*

and music publications, as well as freelanced, before returning to music as a producer in the late 1980s. He played in some other bands, including leading the house band for the television show *Two Drink Minimum* on Comedy Central. Former Tin Huey member Ralph Carney was also in the band, and another ex-Huey, Harvey Gold, was the show's producer. He also played drums for ex-Television member Richard Lloyd for four years before beginning to record some well-received solo albums in the late 1990s. He relocated to Akron a few years back and has been performing with other former Tin Huey members Bob Ethington and Gold in Half Cleveland, as well as in a number of other projects.

Ficca has continued to play drums for various performers. Williams has had a very successful career, releasing a handful of solo albums. He also has played with Liquid Soul, the Psychedelic Furs, Hal Russel and the NRG Ensemble, to name a few. Wormworth has worked as the touring bassist for Sting, Cyndi Lauper and Joan Osborne. She was also a member of the house band for *The Rosie O'Donnell Show* but is best known as the bassist for the B-52s.

In some way, the Waitresses aren't quite as "Akron Sound" as some of the other groups. They never played out in town, as they didn't actually exist until Butler formed them in New York after the demo he recorded with Donahue garnered interest. But Butler, Donahue and Klayman were Akronites, though transplanted in most cases. And the band existed as a pretend project for Butler for a few years before their first real album was released. So they count.

While there was a fair amount of internal strife in their story, they are essentially another Akron group that didn't quite break through. However, unlike most of the others, there are a couple songs that a lot of people outside of the region remember fondly. "I Know What Boys Like" is one of those songs that people are shocked wasn't as big a hit as everyone remembers it being. But Butler is quick to point out that their highest-charting release of any kind peaked at 41, almost a hit. But not quite.

Band Primer

When people remember the Waitresses, they quickly recall Donahue's somewhat talky vocals, awash in irony. But I enjoyed some of the early work before Donahue, with Butler and Sternberg and the imaginary band.

"Clones," from the first single, *Short Stack*, bears a fair resemblance to the songs he would soon be recording with Tin Huey. The song begins and ends

with segments that are technically part of the song but not really that musical. It starts with the character, played by Butler, going through the radio dial, at one point coming across the Numbers Band performing "Jimmy Bell's Still in Town," and ending with Butler yelling for Sternberg.

"Slide" was on the other side of the first single and was just awash in a lot more funk than the first song. It still had the off-kilter sort of art rock that Butler would become known for in the next few years though. It was a great song when you were on the dance floor at your favorite club.

Everyone remembers "I Know What Boys Like." Donahue's vocals aren't especially strong or have much range, but the way she sang with a tinge of contempt makes them memorable and appealing. They were also a band from the era about to explode into video. Everyone understood how to work the camera. It's a great early '80s pop song, which I mean in the best possible way.

"Christmas Wrapping" was another song people remember as a hit, although none really came close to the top 40 singles charts, at least in the United States. But it was an ironically styled Christmas song; written by Butler and sung by Donahue, it really couldn't help but be that.

The theme from the television series *Square Pegs*, much like the previous song, was on the 1982 EP *I Could Rule the World If I Could Only Get the Parts*. The title track had previously been recorded by Butler when he was with Tin Huey.

Their final album, *Bruiseology*, didn't sell as well as their first two releases, but it has some strong tracks on it. "Make the Weather" has a little different vibe than some of their earlier tunes—perhaps a little more positive in tone? Which is odd, as by the time they filmed the video for the song, the band was unofficially finished. With barely more than twenty songs total, they nonetheless left a lasting impression, as there are currently more greatest hits albums in release than actual albums.

LIAM STERNBERG

Liam Sternberg is a bit of a divisive figure when it comes to the Akron music scene of the 1970s. Extremely driven and seen by some as opportunistic, he was certainly successful as the man who produced the *Akron Compilation* for Stiff Records. This is one of the events that put the "Akron Sound" and its performers in front of music fans outside the area.

Chris Butler of the Numbers Band/Tin Huey/the Waitresses remembered meeting Sternberg in the early 1970s. They got together, according to Butler, and played some loud, pointless music that never really came together. Butler described his friend in those days as being "very driven, smart, clever, talented and all that stuff." But he disappeared from Akron for a time. For a while, he was living in England importing American guitars into that country. During that time, his musical tastes grew, and he became very interested in African music among other genres one might hear in London but not Akron.

Meanwhile, Butler was living at the Brady Lake Spiritual Camp, just east of Kent. His turntable was usually kept busy with bands like Little Feat, Funk, Fusion and British Invasion music. Another friend of his, John Gildersleeve (better known as Tommy Teardrop of Tommy Deardrop and the Casualettes), who frequently traveled back and forth between Akron and New York, started telling Butler about the New York scene that was emerging. "After he told me about CBGB and bands like Television and the Ramones, I went to the Kent Community Store and bought a bunch of them." Butler immediately tagged the new scene as being great and the direction he wanted to move toward in his own music.

At about that time, Sternberg showed up back in town and dropped in on his friend, who quickly started playing him the new music he had been

The *Akron Compilation*, produced on Stiff Records by Liam Sternberg. *Courtesy of the "Akron Sound" Museum.*

listening to. Butler still remembered Sternberg listening to the albums and saying, "Yeah, this stuff is great, but we could do better than that."

Sternberg had started to write songs but was now back in Akron and found himself playing in an Elvis tribute band at a local bowling alley—not really acceptable for someone with his ambition. But then came the (locally) famous lunch at a Perkins Pancake House where he and Butler decided that they should come up with some fake bands. Butler's eventually became the Waitresses, and he remembered Sternberg's idea was Jane Aire and the Belvederes—mostly because he always wanted to work with female lead singers and used to have a model of car called a Belvedere.

A story that has been repeated many times over the years has Sternberg walking up to Jane Ashley at the jukebox in a local bar and telling her that he was going to make her a star. The way it's been told over the years is that Sternberg just saw some girl, who wasn't really a singer, but he knew he could turn her into a star. It's a nice story but not exactly true.

Jane Ashley, who would go on to be Jane Aire, had been touring through the South for a while as a singer in a nine-piece show tune and disco band, although she admittedly wasn't that great on the show tunes. They had known each other; in fact, Ashley considers them as being friends already when the genesis of the story actually happened. They were just sitting at the bar talking, according to Ashley, when Liam walked up. Ashley didn't take it all that seriously, as it seems that Sternberg said that to a lot of people in those days. But Ashley did find herself at Dailey's studio with Sternberg, and a number of recordings came out of it. "Yankee Wheels" was one of the more prominent ones at the time.

Meanwhile, Devo was making quite a bit of noise. They had become a known quantity because of the short film *The Truth About De-Evolution* by Chuck Statler, but they had yet to sign with anyone. Because of this, it wasn't that unusual for labels to have representatives in town trying to court them and, if they had time, to listen to what else was going on. After all, the Dead Boys and Pere Ubu had come from just up the road in Cleveland, so it was worth a trip from the label's perspective.

Enter Dave Robinson from Stiff Records. Sternberg made early contact with them and wound up being their man about town very quickly. At one point, a listening party of sorts, probably one of a few, was set up at Bushflow Studios, owned by Tin Huey's Mark Price. Sternberg was not there. Tin Huey, the Bizarros and the Rubber City Rebels had all recorded there, and the studio had a fair amount of recording for Robinson to listen to. Butler remembered Dave Robinson of Stiff Records standing there and

JANE AIRE & THE BELVEDERES

YANKEE WHEELS · NASTY NICE

AN AKRON SOUND RECORDING BUY 26

Sternberg's imaginary group with Jane Ashley, which led to Jane Aire and the Belvederes. *Courtesy of the "Akron Sound" Museum.*

just saying "B-side" three seconds into every song. But somehow, while they were being more or less shot down, Sternberg was becoming tight with the visitors from Stiff Records. Many will tell you that it happened because Sternberg had clear talent and Robinson recognized it; others paint Sternberg as having gone behind everyone's back and showing his opportunistic colors to work with Stiff Records. A third group recognizes it as being a bit of both. Whatever happened, Robinson was eventually convinced that there was enough music in Akron, beyond Devo, to release a compilation album. And Sternberg was the man to put it together for him.

The *Akron Compilation* was a huge moment in the recognition of Akron as a place that pays attention to music. Several of the artists produced their own work: Tin Huey, the Bizarros, Chi-Pig and Butler with the then-pretend band the Waitresses. Sternberg and Dailey produced the rest. Sternberg also played on some tracks as well, using the pseudonym Pietro Nardini, a name with which he also wrote one of the Rachel Sweet songs on the album.

The rest included two Jane Aire and the Belvederes tracks and then one each by Sniper, Idiots Convention and Terraplane. Some of them may or may not have been one-shots recorded simply to fill the album. Also appearing on the album was sixteen-year-old Rachel Sweet, whose career then became intertwined with Sternberg's. After appearing on the *Akron Compilation* album and having released a few singles beforehand, Sweet also wound up on Stiff Records, with Sternberg sharing the producing duties on her first album, *Fool Around*. Depending on whether you are listening to the American or English release, he also wrote either six or seven songs on the album. He also played bass, guitar and keyboard on the album under the name Pietro Nardini.

Sternberg traveled to England with Jane Aire not long after that and put together a group of English Belvederes with her. The band was known as the Edge and counted among its members drummer Jon Moss, who would later

The flip side of the *Akron Compilation* album. *Courtesy of the "Akron Sound" Museum.*

achieve stardom with Culture Club. Sternberg produced and wrote many of the songs for the only album they put out on Virgin in 1979. Sternberg continued to work in the industry, producing and writing, before circling back and working with another Akron band in 1984.

He was working with singer Marti Jones, using her to sing demos, when he suggested she join Color Me Gone, who needed a lead singer. The band, which had a Hammer Damage/Dead Boy veteran on lead guitar, recorded one album for A&M. Supposedly, the deal was arranged by Sternberg, and he also helped produce the EP. While working with Jones, they recorded a demo for the Sternberg song "Walk Like an Egyptian," which eventually became a number one hit in the United States for the Bangles.

Sternberg also had success writing the theme song for the 1987–91 American television show *21 Jump Street*. Over the years, he has continued to produce and write with varying success.

While he was not an out-front, on-the-stage musician (and when he did play on albums it was usually under a pseudonym), his work with Stiff Records on the *Akron Compilation* album, along with producing and writing for acts such as Sweet, Color Me Gone and Jane Aire and the Belvederes, cemented his place in the history of the "Akron Sound" era.

ROBERT CHRISTGAU

The list of people with a hand in creating the "Akron Sound" is somewhat endless. Robert Christgau isn't one of them, as he really did nothing to create the sound itself. He just decided to shine a spotlight on it. Admittedly, he didn't really like the kind of music he heard on his first trip to discover what the scene was all about.

Christgau was already an established critic when he first crossed paths with Akron in 1977. By then, he had spent a few years as a music columnist for *Esquire*, along with a couple of stints at the *Village Voice*, which included having been its music editor, when he got an album in the mail from the Bizarros' Nick Nicholis. *From Akron* featured the Bizarros on one side and the Rubber City Rebels on the other. It was released by Nicholis's Clone Records. He had been given a list of important people to send the album to by friends in the Cleveland band the Dead Boys.

Christgau reviewed the album, giving it an A-, and commented very positively on the effort: "A self-produced album showcasing ten good songs is a pleasant shock." He made some comparisons to the Velvet Underground, in both Nicholis's vocals and the band's "deliberate discordances," but went on to say that "the stoopider approach of the Rubber City Rebels...proves more foolproof."

It might have ended there if Chris Butler, then the bassist of the Numbers Band (15-60-75) and soon to be a member of Tin Huey and eventually the Waitresses, hadn't become a little tired of reading Christgau go on about the music scene over in England and in New York. Butler described the letter he sent as asking a bit forcefully, "Why don't you take a look in your own backyard. There is a great scene over here in Northeast Ohio with kids packing the clubs to hear originals bands." Christgau wrote, "Last spring

there was a smart, rambling letter from a guy in Kent, Ohio, with a smart, rambling album to match—on Warner Bros., by a group that seemed to call itself 15-60-75 the Numbers Band." That was Butler's band at the time when he sent the letter but not when he heard that Christgau was coming to town. At that point, he had been in Tin Huey just a few weeks, and he and the other members of that band threw together a packed show on a Friday night at JB's in a very short time for the incoming guest. At that point, Tin Huey was playing in front of much smaller crowds on the slower part of the week. Fliers, word of mouth and Butler's fanzine *Blank* created the buzz. Christgau also wrote in his article on the show that Butler had been sending him *Blank* on a regular basis. He arrived in March 1978, and the *Village Voice* published his article on the visit on April 10, 1978.

He wrote about Butler's imaginary band the Waitresses, which gave them an interesting history, as most bands don't have internationally known music critics writing about them before the band is actually formed.

Christgau wrote about going to see the Numbers Band (15-60-75) at a jazz club called the Bank downtown. In a few years, it would be a hotspot for the originals bands in the region; in early 1978, it was a jazz club not really pulling in crowds. He visited JB's on March 10 and saw Tin Huey and the Bizarros. The owner told him it was the biggest Friday night in JB's history. While he was upstairs, the Numbers Band (15-60-75) were filling the place downstairs.

Christgau spoke well of the Bizarros, even more so of Tin Huey. Oddly enough, he also noted that he usually didn't like their style of music, but he was intrigued enough to bring Karin Berg of Warner Bros. a few weeks later, and they wound up bringing Jerry Wexler not long after that. Christgau didn't really discover the scene, as some claim. Devo and the Rubber City Rebels were already signed, although the Rebels' album didn't come out until they were on their second label. And Cleveland's Pere Ubu and the Dead Boys had broken through a little and were part of the local scene as well. But he did champion the local music, and bringing a Warner Bros. exec to see Tin Huey did a lot to advance that band and get them a major record deal.

A few of the local musicians referred to becoming friends of a sort with Christgau, and some mentioned that they felt he really enjoyed having "discovered" a scene somewhere. After all, he was a rock critic. Regardless of whether he did or not, the April 1978 article in the *Village Voice*, titled "A Real New Wave Rolls Out of Ohio," was a big boost for the region's music. So even if Christgau never picked up an instrument or stepped on an Akron or Kent stage, he greatly added to the idea of an "Akron Sound."

THOSE WHO PLAYED AN "AKRON SOUND" SOMEWHERE ELSE

Not all the musicians who called the area home, or whose musical growth occurred in Akron, made their debuts or even played in Akron. But their music was no less part of the "Akron Sound" than that of the bands that regularly played at JB's, the Crypt or the Bank. They still spent their formative years with some of those same influences, and they still had some influence on those who were part of the region's scene.

Chrissie Hynde of the Pretenders, along with her own solo career, is a perfect example. From the perspective of the local music scene, she was the little sister of saxophonist Terry Hynde, best known as a longtime member of the Numbers Band (15-60-75). More than one other local musician remembered her telling folks she was going to be a star someday long before she traveled to England and formed the Pretenders.

In the late 1960s, Hynde helped sew the costumes the Poor Girls wore when they opened for national acts at the Akron Civic Theater. Hynde was a close friend of Debbie Smith, bassist for the Poor Girls and eventually Chi-Pig, with several bands in between. Harvey Gold of Tin Huey remembered driving around with a group of friends in the early 1970s and singing as they drove, never even thinking that Hynde had a great voice or considering that she was not that many years away from superstardom. She was for many of the local musicians in the early 1970s a friend and Terry's little sister but not part of the scene itself.

But like a number of local musicians, she had been affected by the Kent State shootings in May 1970, as the boyfriend of a friend of hers was killed during the shootings. A few sources have her briefly in a band called Sat Sun Mat with future Devo leader Mark Mothersbaugh, a tenure that lasted just one night on a stage and is the only time she played out before leaving for Europe.

Her 1982 single "My City Was Gone" reflects on how much Akron had changed during her years in England. Still, she returned to Akron often, opening a vegetarian restaurant in Akron in 2007. She also performed at a fundraiser for the Summit County Democratic Party in 2008 with Mothersbaugh and the Black Keys.

Another major player who came out of Akron but rarely if ever played out in the area was Erik Lee Purkhiser. Better known as Lux Interior of the rockabilly punk band the Cramps, he was born and grew up in Stow and left the area right when the earliest notions of a scene were starting to

Chrissie Hynde at the Civic Theater in 2008. *Courtesy of Bruce Ford.*

bubble up. He did return for a short time in 1973–74 before he left for New York and the Cramps hit their stride, becoming a significant band in the punk movement. He died in 2009, leaving a significant recorded history. His brother, Michael, played in both the Action and the Walking Clampetts, which were both very active in the second wave of the "Akron Sound."

A third artist who was both somewhat part of the local scene and yet had much bigger success elsewhere was Jane Ashley, better known as the front for Jane Aire and the Belvederes. Repeated over and over again is the story of how Liam Sternberg walked up to Ashley at a jukebox and told her that he was going to make her a star. According to Ashley, that was sort of true. She knew Sternberg well at that point and considered him a friend. And one day, while sitting at the counter of a local bar, Sternberg told her that someday he would make an album with her. Ashley had been a singer in a nine-piece show tune and disco outfit that toured most of the South at that point, so a solo album in her future wasn't a stretch. Ashley will tell you, though, that her sister, Joan, who passed away in 1985 at the age of thirty-three, had the superior singing voice. Joan Ashley was also known as a radio personality on country station WSLR.

Sternberg took Jane Ashley into the studio and recorded some songs with her, releasing a single here in the United States and placing a song on

Jane Ashley with George Cabanis of Hammer Damage, Color Me Gone, the Bad Dudes and the Dead Boys. *Courtesy of the "Akron Sound" Museum.*

the *Akron Compilation*. She and Sternberg went to the UK, and not long after that, she released a few more singles and one album. To this day, Ashley considers herself as more of an English artist than an American one, in large part because her only album and most of her singles were only released in the UK and can only be found here by import.

The first set of Belvederes included Sternberg. When they got to the UK, she took in a band called the Edge, which included drummer Jon Moss, who eventually found fame with Culture Club. Later, her brother, Dave Ashley, came over and was a Belvedere. In the early 1980s, he drummed for the Bizarros and was in numerous bands in Akron. While Jane Aire and the Belvederes never

A Stiff Record promo for Rachel Sweet. *Courtesy of Chris Butler.*

played the clubs in the area during the heyday of the late 1970s and early 1980s scene, she was clearly part of it. She has her position secure in the "Akron Sound."

Rachel Sweet is another performer who appeared on the *Akron Compilation* and has continued to have a nice career in the entertainment business without ever setting foot on one of the stages within the scene in Akron. Sweet had been a star of sorts for a number of years. She had some regional country success and even played Vegas before Sternberg turned her into a pop princess, playing a little on the Lolita theme while writing and producing her for a few years. She appeared on the *Akron Compilation* and was signed by Stiff Records afterward. She had a few minor hits both here and overseas and for the past twenty years has been a writer and producer of numerous television shows.

While these four acts never really became part of the musical scene in Akron, they greatly contributed to it in various ways and really should be considered part of the "Akron Sound."

Robert Quine is an artist who was gone long before things started to really get going but whose music certainly fits into what eventually developed in Akron. By 1969, he had become the man who taped the Velvet Underground shows and eventually had an official release with his liner notes in 2001.

He worked at a retail store with future Television members Richard Hell and Tom Verlaine and eventually became the guitarist for Hell's band Voidoids. It was there he became a critical smash (though not with the accompanying fame) as a punk rock guitarist. It's impossible to read about him without seeing claims of him as the inventor of the punk rock solo and just general critical acclaim.

Commercially, his peak was as Lou Reed's guitarist in the early to mid-1980s. The 1982 album *The Blue Mask* was amazing in the way Reed and Quine's guitars worked with each other. Personal problems with Reed, a common theme with many musicians, and a hatred of touring caused him to quit that band and work as a studio musician for a number of years. Some biographies now like to describe him as a cousin of the Black Keys' Dan Aurbach, which he is, but they are second cousins once removed.

ALL THOSE OTHER GREAT BANDS

For all the groups that got major record deals or even got a fair amount of national airplay, there were so many others that were so very good in their own right. Maybe they only made it to the upper echelon of the area for a short time, or perhaps they didn't have quite as good of an originals song catalogue, but they are still part of the "Akron Sound." More importantly, these bands are remembered with excitement by a lot of people in the area who found themselves out in clubs in the late 1970s and early 1980s.

There were, of course, the bands that weren't exactly Akron/Kent groups but still played a whole lot around the region. It's hard to talk about going out to see great bands in Akron/Canton back then without talking about Pere Ubu, the Dead Boys, the Human Switchboard and the Wild Giraffes from Mentor—all great bands that added a lot to Akron's music scene but weren't exactly Akron bands. They were Cleveland bands that played a lot in Akron, but that isn't quite the same thing.

The Action formed in the very late 1970s as an Akron band. They were made up of guitarist and singer Mike Purkhiser, bassist Brent Warren and eventually drummer Cliff Bryant. Purkhiser and Warren had already

Flier promoting the Action's upcoming dates. *Courtesy of the "Akron Sound" Museum.*

released a 7-inch single before Bryant, known for his Keith Moon influence, joined them in 1979.

They released two more singles, "She's Got My Heart" and "Radio Music," as well as played shows in New York City and Chicago. Tracey Thomas, Unit 5's lead singer at the time and in several other projects since

then, remembered always making sure that she and her girlfriends made it to their shows, as the Action were just great to dance to. With influences from the Kinks and the Who, they played a blending of '60s rock with an attitude.

Trudee and the Trendsetters were sort of like Tom Petty joined with the Talking Heads, and they played really fast with a lead singer women just swooned over. Tony Bandrowsky was actually Trudee; as the story goes, he thought it was a funnier name than Tony and the Trendsetters. Bob Basone, who has held down the bass chores in countless Akron bands, was also in the band.

The Nelsons were known as the area's premier surf band at the time, in large part because they were really good and there wasn't much competition for the title. They were only active from 1979 to 1981 but left quite an

Left: Promotional image of Trudee and the Trendsetters. *Courtesy of Tracey Thomas.*

Below: The Nelsons, Kent and Akron's premier surf band. *Courtesy of Jimi Imij.*

impression. They followed one of the current trends in music by everyone taking the last name Nelson. They were a lot of fun in the way only a good surf band could be.

If there was another band that deserved its own chapter in the story of the "Akron Sound," it would probably be the F-Models. Aggressive rock-and-roll was their calling card—along with great songs, mostly written by Iggy Morningstar, who called himself Ig Nition at the time, and a really tight band. Supposedly, they formed as the Models, a few of them having been in earlier bands, and were known enough that there was a buzz before they even took the stage. Donny Damage of Hammer Damage started calling them the Fucking Models even before their first gig. When they found out there was another band called the Models, they decided to go with the more family-friendly F-Models. They were only together from 1980 to 1983 and never released an official album, but there is a fair amount of recorded history. A number of those songs wound up on the set lists of other Akron bands. "Nobody Loves Me (But My Mom)" was heard on Akron stages a long time after the F-Models stopped playing together.

In 1981, five Kent State students, who happened to be all women, formed the Bettys. Turning the "everyone in the band has the same name" thing on its head a bit, they all took the first name Betty, with different last names, none that were actually their own. Their self-produced album, *Music Saved My*

The F-Models loved drawings of this type to promote themselves. *Courtesy of the "Akron Sound" Museum.*

Soul, released on cassette, just rocks. Their time in Kent was really just from 1981 to 1982, but they were good and still resonate to this day, in large part because a few of them are still recording. Betty Brown, now and previously known as Diane Glaub, found herself in the San Francisco band Sounds for Emma with another former area player, 0DFX's Tommy Strange. Before that, she and Betty Cakes, better known as Jennifer McKitrick, were in another San Francisco band called Swinging Doors with yet another former Kent Stater named Dwight Deen. *Music Saved My Soul* is a great listen.

The Diffi-Cults were all about playing fast, much like a lot of Akron bands from the time. Only releasing the 1986 single "Day of St. Christopher," the band was a staple of the Akron music scene from 1983 to 1992. Led by Dave and Ralph Giffels, the band played regularly through the 1980s before they recruited another brother, Louis, of the Twist-Offs, for another band, Jiffo.

Dave Giffels is now a well-respected writer and coauthored *Are We Not Men: We Are Devo!*, as well as many other books, with several on Akron. He has been a commentator for NPR and is frequently called on as a chronicler of the area's culture.

Color Me Gone actually did have a major label release, an EP with A&M Records that was well received critically in 1984 but didn't resonate with

Cover of the *Color Me Gone* EP. *Courtesy of the "Akron Sound" Museum.*

fans. George Cabaniss of Hammer Damage and the Dead Boys formed the band but hadn't settled on a lead singer when he was introduced to Marti Jones by Liam Sternberg, who had produced a number of Akron artists. Their EP is extremely good and by rights should have been a much bigger hit than it was. Jones went on to a long and extensive career as a solo artist and has appeared on albums by Marshall Crenshaw and Joe Cocker. Cabaniss also still plays in the Akron area with the Bad Dudes.

The High Plains Drifters were a little late to the party but no less significant. Over the years, they've gone through a lot of members. They are an interesting blend of metal, punk, country, blues and whatever gets thrown into the blender

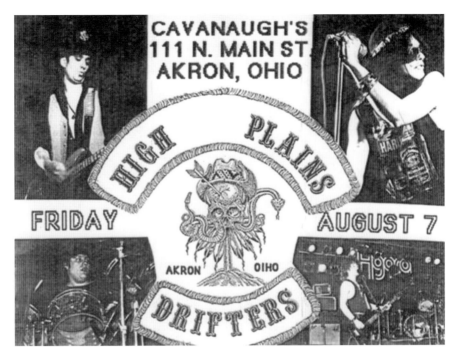

High Plains Drifters flier for an upcoming show at Cavanaugh's in Akron. *Courtesy of the "Akron Sound" Museum.*

that night. They've been known to cover AC-DC, Hank Williams, the New York Dolls and MC5 during the same show. And that doesn't even take into account their originals, which were just as eclectic.

They released a single in the late 1980s and then three albums in the 1990s. The wonderfully named *These Songs All Suck: A Decade of Stupidity* came first. In the late 1990s, Kal Mullens of Hammer Damage, Teacher's Pet and the Bad Dudes produced a few albums for them, including a live effort in 1998 at Annabelle's. The High Plains Drifters play somewhat sporadically at this point but still play a few times a year, including the Rubber City Rumble on the years they hold it.

Teacher's Pet came together when Ron Mullens, then known as Pete Sake, parted company with the Rubber City Rebels and they headed off for Los Angeles. Mullens joined his brother Kal's cover band Wizard. But as soon as they started writing their own songs, a name change was needed and Teacher's Pet was born. Teacher's Pet was much like the High Plains Drifters in that their style was very eclectic—power pop, garage rock and a little punk and glam. Mullens's organ sounded nothing like the

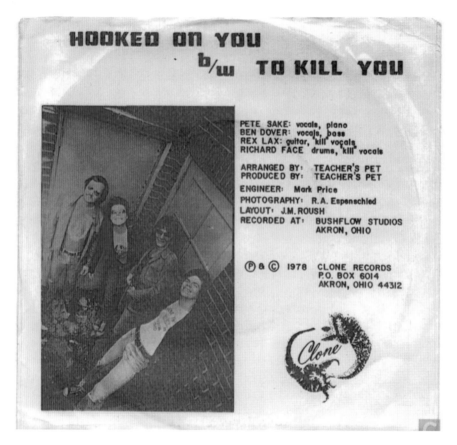

Teacher's Pet Single "Hooked on You/To Kill You," one of the many releases recorded at Bushflow. *Courtesy of the "Akron Sound" Museum.*

other keyboards of the day—a lot less pop and a lot more in your face. Kal Mullens currently plays in the Bad Dudes with Cabaniss of Hammer Damage/Color Me Gone/Dead Boys. They released a single in 1978 and then recorded an album in 1979. But for various reasons, the album didn't get released until 2008. They still play out now and again like so many of the other bands from their time.

Some of the Walking Clampetts will tell you that they were just a cover band, as they didn't do a lot of originals and weren't hoping to get signed. They focused on surf instrumentals and '50s rockabilly and were certainly very different from so many of the other bands out at the time, at least those bands people included in the "Akron Sound." Mike Hammer claimed that the name came out of their walking bass sound, not a staple of punk or new

The original Teacher's Pet. *Courtesy of Kal Mullens.*

wave. But the band had Hammer, the Basone brothers, Johnny Teagle and Mike Purkhiser, so the pedigree was there. But unlike a lot of their peers, it was about playing out, having fun and making some cash, not chasing a record deal. And the Clampetts did all those things. According to some band members, though, there is a four-song demo of originals that was recorded that the band felt wasn't up to their standards.

The Hi-Fi's billed themselves as a rocking dance band. They had no problem covering Buddy Holly and the Beatles, but they gave them a great twist and added a lot of originals to their mix. I remember hearing them on WMMS's *Coffee Break Concert* at the beginning of my senior year in high school. It was September 18, 1981. The *Coffee Break Concert* was a midday show, usually on Wednesday, that featured a national touring act that was in town to perform. But it was cool to have a local group, guys right down the road, playing on it. I didn't know it at the time, but the drummer was Richard Roberts of Chi-Pig. A number of bands drew inspiration from the 1950s and 1960s in the second wave of the "Akron Sound," and the Hi-Fi's were second to none.

0DFX was hardcore punk in a way that hardly anyone else was. Their lead singer, Jimi Imij, remembered hanging out behind the Crypt at night when he was sixteen, craning his neck to hear the bands. 0DFX specialized in songs about one minute long that were full throttle. The band itself, and especially Imij, has been a major factor in the area's

 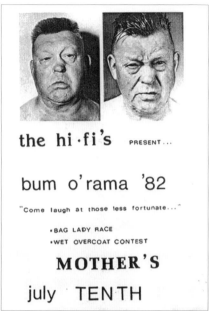

Left: The Walking Clampetts in a flier promoting the band. *Courtesy of the "Akron Sound" Museum.*

Right: Flier for a Hi-Fi's show at Mother's Junction in Kent. *Courtesy of the "Akron Sound" Museum.*

music history. Nobody has put more effort into chronicling the musical history of the area than Imij.

And while they were hardly punk, new wave or even rock, there were some other musicians from Akron having success during this time that should be mentioned. David Allen Coe was and is country—no question about it. In the very early 1970s, he did play some Akron locations where musicians who would become part of the scene played. Harvey Gold of Tin Huey once lent Coe his guitar when they were both playing a coffeehouse called the Avalon in the very early 1970s. Coe has recorded more than forty albums over the last fifty years. He peaked essentially at the same time the Akron music scene did, from 1975 to 1984, scoring three Top 10 singles and two Top 10 albums on the country charts.

Howard Hewett grew up in Akron but left here in 1976 at the age of twenty-one. He was a member of the R&B group Shalamar by 1979 and has had a long career with them and as a solo artist in both R&B and gospel.

The Ingrams, James and Philip, also had considerable success as R&B artists during the era. James released a number-one single, "Baby Come to Me," with Patti Austin in 1982. Philip had success as a member of Switch, who recorded in a Motown style from 1977 to 1983.

The list of great musicians who came of age in the 1970s and early 1980s is endless. While some great groups have gotten overlooked on this list, this is as good a list as any. Search them out if you can because while they didn't reach the upper echelon of the "Akron Sound," it wasn't because they didn't have some great songs worth hearing.

0DFX at Electric Ladyland in New York City. *Courtesy of Jimi Imij.*

THE PLACES

THE CRYPT

For most of Akron, it was just a lonely black door across from a Goodyear plant at 1399½ Market Street. If you entered through that black door any time before the end of 1976, you'd meet up with a bunch of rubber workers having a few beers after, or even before, their shift. During the summer of 1976, they'd be hanging out there all day when a long rubber strike was going on. It was not a place you'd imagine becoming one of the important bars in the Midwest punk scene that was exploding in the 1970s. But for a short time in 1977, it was just that. It was *the* place—ground zero for the Midwest.

King Cobra, the hard rock covers band that eventually would become the Rubber City Rebels, played there quite a bit in late 1976 and would often fill the place at night after all the rubber workers went home. The owner, Bill Carpenter, was a rubber worker himself, albeit one who was getting really tired of trying to run a bar that didn't really make all that much money. The Crypt suffered through the long rubber strike, and the bar had limped through while its core customers weren't drawing paychecks; once the strike was over, the bar didn't really show signs of rebounding.

Whether the idea just came to him or he had been thinking about it for a while, one day in late 1976 he threw out an idea to King Cobra. It may have been that Rod Firestone and Buzz Clic were there talking to him about

booking a few more shows at the bar; in another version, it was while the band was actually setting up for a show—memories are cloudy after forty years. Clic remembered him just casually saying that they were the only band that made any money at the place and they should just take over the bar and run it—all they would have to do is keep up the lease.

Clic said that Carpenter was a nice enough guy, but he had been running the club for a few years and he knew exactly how much money the bar brought in. The way it was set up, the bands got what came in through the door, and he was getting all the money the bar took in. He knew exactly how much the bar was going to make, so that was the amount of rent he offered to charge the band. Because of this, they were never really able to make any money. Clic pretty quickly started hating going in there because they had to actually work. He described it as being just like having a real job. Firestone agreed, calling it very hard work.

So, instead of being rock stars, they wound up spending their days scrubbing down bathrooms, stocking beer coolers and serving up beer to either guys getting off an overnight shift or retired guys from the neighborhood. After that, though, they got up on the bar's stage and put on shows that people still talk about.

Even after the Rebels took over the club, it still remained a rubber workers' bar until show time. During the day, it was full of guys having beers, shooting pool and playing pinball. According to Clic, it was the kind of place that when somebody was near retirement, the other guys would pitch in for a stripper to come and dance on the pool table on his last day. At night, the Crypt was a completely different bar.

But whether day or night, you entered through the black door on Market Street and descended a steep set of stairs—every musician who played there remembered the staircase as seemingly built to make hauling instruments and equipment up and down as difficult as humanly possible. When you finally got to the bottom of the stairs, you were greeted by a long bar on the right-hand side as soon as you walked in. It was one of those bowling alley–style rooms, a long narrow hall with the bar running along the entire right side of the room.

On the left side was a stage, which the Rebels rebuilt as soon as they started running the club. And much like any bar in the 1970s, it had a pool table, some pinball machines and a jukebox. It could fit maybe 150 people if you worked hard to pack them in. It wasn't really much as bars go.

But King Cobra, who became the Rubber City Rebels the second or third night they were running the club, knew Devo, the Dead Boys, Pere Ubu and

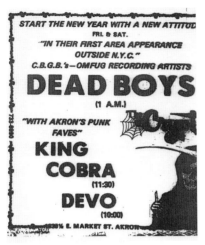
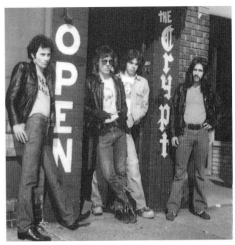

Left: The flier from the first night the Rebels took over the Crypt. Their friends the Dead Boys had their first show outside New York City there. *Courtesy of the "Akron Sound" Museum.*

Right: Eventually the cover of the Rebels' *Retired* album, the band is seen here standing outside the bar they ran. *Courtesy of the "Akron Sound" Museum.*

the Bizarros and figured that they could book them to play at their bar and they wouldn't have to play every night and could also make money from booking the other bands. It seemed to Firestone like a great idea, although the rest of the band was a bit more apprehensive. Whatever arrangement they made with one another, the Rebels became bar managers.

Firestone remembered his and Clic's wives being the saving graces. As Firestone pointed out, "They could add numbers and shit." They handled all the bookkeeping and ordering, and the band would handle all the booking. Firestone admits today that the wives held it together for them, as it was way more work than he had imagined.

They installed their band's PA and sound board in the club, which greatly helped the sound in the club. And they started talking to some friends. They had known most of the Dead Boys when they were in various Cleveland bands before they headed to NYC to become a regular act at CBGB's in New York City. The Dead Boys helped kick off the Rebels' running of the club by showing up to play a few nights, and the shows were billed as the Dead Boys' first shows outside New York City. Devo's *The Mongoloid Years* included a few recordings supposedly from that night.

Eventually, though, the biggest draw at the club became Devo. According to both Firestone and Clic, their fans never drank and didn't help the bottom

line of the club in any way. They would bring in their juice and not spend any money, according to Clic. "You'd think the place was happening, but at the end of the night the bar didn't make anything."

A legend has grown around the idea that there was a pretty heated rivalry between the fans of the Dead Boys and those of Devo. It was said that fistfights between the two fanbases, which occasionally involved band members, would break out.

Clic remembered the rivalry as being blown out of proportion. According to him, it was actually just one night in December 1976 (perhaps even New Year's Eve) when Cheetah Chrome of the Dead Boys, who might have been a little drunk and was egged on by the

Rebels drummer Stix Pelton playing pool at the Crypt. *Courtesy of Jimi Imij.*

other Dead Boys, thought it would be funny to pants Devo's Booji Boy on stage, which got things really going.

But according to Clic, the idea that there was any kind of rivalry that lasted between the bands past one drunk night isn't really true. It's also untrue that the bands' fans ever threw punches at one another. Clic actually found the idea laughable, remembering, "Geez…they didn't hardly drink and they brought in their own sparkling water."

The club had other problems, though, which Firestone referred to as the band's "adventures." One especially scary period happened not too long after they took over. At the time, according to Firestone, whenever a new bar would open in Akron or be taken over by new management, the local biker gangs would send in a member wearing colors to order a beer. If the bar served the biker, before you knew it the bar would be full of bikers and the street outside would be full of motorcycles.

That became a problem pretty quickly. It seemed that the bikers and the college students who came to listen to Devo didn't mix at all. In fact, when the bikers showed up, the Devo fans would leave. Firestone remembered Devo telling him that he had to do something or there would be nobody left in the bar but the bikers. It came to a head one night when a bunch of

The Rebels' Buzz Clic. *Courtesy of Jimi Imij.*

bikers came in while Devo was playing and the college kids all started taking off. Devo told Firestone he had to do something then and there, as the place was quickly clearing out.

Firestone, looking back, remembered that he was pretty young and dumb at the time and went looking for Peter Fonda, as all he knew about bikers is what he saw at the movies. He asked the bikers who the leader was, and he was answered by a pretty scary-looking guy who told him he was. Firestone then told the guy he'd give them back all their money they had spent that night and a case of beer but he would appreciate it if they left.

It didn't go as he had hoped. The bikers got angry and told him they weren't going to leave. Firestone said he tried to explain to them it wasn't personal, but they were scaring the people who were there to watch the band. Luckily for Firestone, his wife saw how bad the situation was getting and called the police while the conversation was going on.

Firestone said that at one point, as he was starting to contemplate his own death, the police she summoned showed up. One of the officers took him and the leader of the bikers out in the stairway and tried to explain to the biker that the bar could refuse service to anyone they wanted. They were offering them their money back and throwing in some free beer on top of it, so why not leave? Firestone still remembers the biker looking at him and saying, "Okay, we'll leave. But you're a dead man."

Luckily for the future of the Rubber City Rebels and Firestone, the officer continued to work out a deal where the bikers would agree to not wear any colors in the bar showing they were in a biker gang and the bar would serve them. Firestone lived and Devo was satisfied, as the bikers behaved. So, the club went on for five or six months with a number of just incredible Akron and Cleveland bands playing legendary shows on its small rebuilt stage.

But then Holiday Inn made an offer to buy the liquor license from the bar's owner for $14,000, which was way too good for him to pass up. According to Firestone, though, he told the Rebels that he could get them

another liquor license and they wouldn't have to pay any money. A meeting was quickly set up with what Firestone remembers as either the mob or a group mobbed up.

They explained to the Rebels that they could find themselves with a new liquor license for nothing down and they could pay for it with their half of the pool table and pinball money. Up until then, the bar had been splitting that money with the helpful fellows now offering to get them a liquor license. Firestone thought it didn't sound like a good deal at all, especially when they started talking about how they could get another pool table and a few more pinball machines in the bar.

So, the Rebels bailed and headed first to New York City to play CBGB's and then in a few months to Los Angeles to start the second phase of their career. So the Crypt was no more, and Holiday Inn had a liquor license. Eventually, the building was destroyed, and now a car dealership sits on the epicenter of the "Akron Sound." And even though the bar has been gone for years, it's immortalized on the cover of the *From Akron* split album that the Rebels and the Bizarros released in 1977—for anyone who wants to remember what that entrance looked like.

A few years ago, a documentary was made on the "Akron Sound" called *It's Everything, Then It's Gone.* The title perfectly describes the short and incredible life of the Rubber City Rebels–managed club. For a short time, it was the coolest bar in town, maybe even the Midwest.

THE BANK

The Crypt's story was a bit different than the Bank's, where an adult ran the bar, which may explain its longer success and, in a way, its eventual demise. Howard Allison was an attorney who practiced in Kent in the 1970s before moving his practice to Akron in 1979. He also wanted to, and did, open up a jazz club on South Main Street in Akron, Ohio. The jazz club was on the national circuit for touring performers—not as odd an idea in the mid- to late 1970s as it seems today, as just a mile or so away on Howard Street, a few jazz clubs had existed for many years during the midcentury and they had certainly been host to jazz's elite.

He opened his jazz club on the first floor of the Anthony Wayne Hotel downtown. When the hotel, then known as the Hotel Bond, was opened in 1917, Akron was a city exploding in population. The United States Census had Akron growing from 69,000 to 208,000 between 1910 and 1920. Nice

The parachute that hung from the Bank's ceiling. *Courtesy of the "Akron Sound" Museum.*

downtown hotels were in demand, and they were popping up. And while many had restaurants or even nightclubs on their first floors, the Hotel Bond had the Commerce Saving and Trust prominently situated on its first floor. This was convenient for Allison some sixty years later, as he used the bank vaults to store beer and other spirits.

Eventually, the Hotel Bond was renamed the Anthony Wayne Hotel after the Revolutionary War hero sometime in the mid- to late 1930s. The hotel eventually began its decline into more or less a flophouse with an empty bank location on its first floor. But then along came Howard Allison. A 1969 graduate of the University of Akron Law School, Allison had a history of cases involving fireworks and the First Amendment and served as an official with the ACLU in the mid-1970s. He is also remembered by Akronites as an ambulance chaser, a bit of a roguish character involved in some of the sketchier aspects of Akron, specifically the drug culture. Whichever he was, civil rights champion or ambulance chaser, he decided to open a jazz club in downtown Akron in the late 1970s.

Bob Ethington of Unit 5 and Tin Huey remembered going to see musicians there in the late 1970s, some with a national following, and having thirty

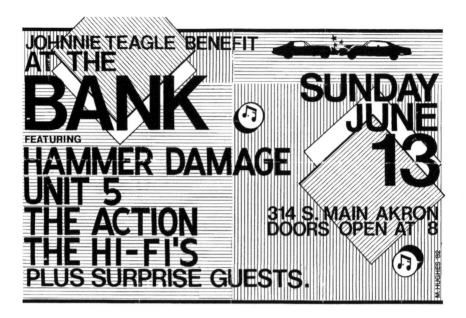

Flier for benefit show at the Bank for Johnnie Teagle of the Walking Clampetts after a serious car accident. *Courtesy of the "Akron Sound" Museum.*

people in the audience. The club was only open the busier nights of the week and did not make a hard turn from jazz to punk/new wave, as some seem to remember. Robert Christgau mentioned going to the jazz club the Bank to see the Numbers Band (15-60-75) when he came to town in early 1978. So Allison had started to make the gradual change in his bookings by then.

The building itself wore its charm well but was perfect for a rock club. Even with marble and chandeliers from its time as a prestigious banking institution, it still showed decades of wear and had clearly seen better days. Decaying wealth was a perfect décor for a club like the Bank. By the time it had become a new wave/punk club, there was a large piece of fabric on the ceiling, always reported to be a parachute. Many assume it was to add to the culture of the less than mainstream music, but insiders know that it was meant to catch debris from the crumbling ceiling from falling on all the people dancing. It was a legitimate heir to the Crypt, though, as instead of being in the shadow of the Goodyear facility, it sat in the shadow of the Goodrich facility. Harvey Gold of Tin Huey remembered it being a big black box inside. "It was like Akron's Irving Plaza."

According to some involved, the change at the Bank occurred because a group of musicians went to Allison and persuaded him to change it into

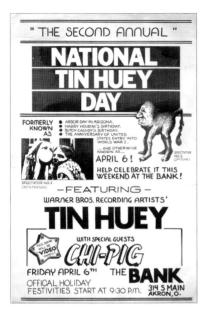

A poster promoting the second annual Tin Huey Day with Chi-Pig. *Courtesy of the "Akron Sound" Museum.*

a rock club so they would all have a place to play. Debbie Smith of Chi-Pig remembered it as just that simple, saying, "C'mon, Howard, start booking us." Akron's sparsely attended jazz club became a packed rock club.

Very quickly, I assume to Allison's liking, Chi-Pig, the F-Models, Tin Huey, Hammer Damage and Unit 5 were filling the place every night it was open. Gold remembered the stage being very small, though, at least for Tin Huey, and they needed to move their drummer to a separate location above the stage so everyone could fit. Of course, they were a six-piece; the four-piece bands managed it a bit better.

One of the memorable events at the Bank happened after Chi-Pig did some New York City dates and met Klaus Nomi and his manager. When told that Nomi was looking to tour outside of Akron, the members of Chi-Pig told him all about the Bank and invited him to come and perform there. He did, taking Akron by storm in the summer of 1980. Nomi received front-page coverage in the Sunday arts magazine *Enjoy* from the *Akron Beacon Journal.* Photos of Nomi and his bandmate Joey Aries exploring Akron were seen all through the newspaper. The image of Nomi on the cover of the *Beacon* magazine with the headline, "This guy thinks Akron is pretty unusual" is still etched in a lot of Akronites' minds.

Tin Huey played there when they got back from California after their Warner Bros. album came out, but they left for New York not long after that and weren't really a constant presence at the club after a time. The F-Models were more Kent based. So that left a rotating calendar of Hammer Damage, Chi-Pig and Unit 5 as the headliners at the club. There were many other bands who called it home though.

The place was jumping, much more than the Crypt. The second wave was perhaps a bit more accessible, and the club was in a better location that allowed for bigger crowds. But then either the scene ended or, as some like to claim, they tried to fix the place up and make it look like a real nice club and it completely ruined what made the Bank what it was.

The stage of the Bank from the dance floor. *Courtesy of the "Akron Sound" Museum.*

The Bank closed around 1983, and the Anthony Wayne followed suit a few years later. In 1996, the building was demolished along with the entire block to make way for the AA baseball stadium that went up downtown. And just like that, it was gone.

In the last decade, though, a club called the Bank, with live music, opened up within walking distance of the original Bank. While there were some good Akron bands playing there, it wasn't the same and the club didn't last.

JB's

In many ways, JB's was where the "Akron Sound" both started and ended. Joe Walsh's the Measles played there in the early 1970s. As did the Numbers Band (15-60-75), which held court playing both stages for years—in those days, nobody said they were playing JB's but rather specified what floor and stage they were playing, named of course JB's Up and JB's Down; even the fliers and posters made it clear. It was easy for all the music fans to find the bands they wanted to listen to and perhaps not mix with fans of other

The Rubber City Rebels on stage at JB's. *Courtesy of Jimi Imij.*

groups, or styles of music, unless they wanted to. Many musicians from the era tell stories about the antagonistic attitude between the hippies, bikers and blues fans and the art rock, punk and new wave fans. And some will tell you stories about how they fought among themselves.

Mike Hammer of Hammer Damage will claim to this day that they only added some Steppenwolf to their set lists, which became huge fan favorites, so the bikers wouldn't get mad and try to start fights with people who came to see them at JB's. Tracey Thomas of Unit 5 remembers being spit on for having multicolored hair.

JB's might have had a little different vibe since it was a Kent bar instead of an Akron bar. Depending on the show, you'd have a lot more college students at shows at JB's than probably were at the Crypt or the Bank. Not that those two clubs didn't draw their fair amount of students as well. But it was a college bar at the end of a strip of college bars—244 South Water Street to be exact. On the other hand, you'd draw a lot more folks there to hear hard rock or blues. The two stages gave JB's an even more eclectic feel than the other bars.

In the early to mid-1970s, there were separate entrances to Up and Down, with the stairway to Down being almost as impossible to carry amps and gear down as the one at the Crypt. Both Up and Down could fit 150 or so people, although Tin Huey remembered only get about 25 to 30 most nights. Both stages were on the right side of the building, with the bars on the left.

But when the Crypt in Akron was starting to take form, JB's already had a history of originals bands playing both Up and Down. And some of the "Akron Sound" bands were already playing on JB's stages, although sometimes for the strangest reasons. The members of Tin Huey all swear that the only reason they were given a few nights per week at JB's Up is because the bar manager was a huge Grover Washington Jr. fan and liked the idea of having a band that had a sax player in it.

The famous shows that included Tin Huey, the Bizarros and Chi-Pig that Robert Christgau wrote about in the *Village Voice* were at JB's Up. Tin Huey had been playing the less than prestigious nights of Sunday through Tuesday at JB's Up when Christgau told them he was coming to town. Chris Butler of Tin Huey remembered JB's owner, Joe Bujack, not being real difficult to talk into giving their band some weekend nights to showcase the band, although he made Butler promise that when they became big stars they wouldn't stop playing his place like Joe Walsh did. According to the article Christgau wrote, though, that first Friday showcase was the best night sales wise during his ownership.

After that, JB's became a home for a lot of the "Akron Sound" bands, especially after the Bank closed in the early 1980s. JB's more than just shouldered on, though, becoming much more of a national destination than the Crypt or the Bank ever did. Black Flag, Husker Du and the Red Hot Chili Peppers played there before they became stars, and the bar stayed open until around 2000.

In the early 1980s, there was a long list of bands that were part of the second wave of the "Akron Sound" that played JB's. It did reopen under the name JB's a few years back, as the location had been a bar of some sort during the years in between, albeit with different owners.

BUSHFLOW STUDIOS

There were other recording studios in Akron in the late 1970s and early 1980s. A number of acts even made the drive up to SUMA Studios in Painsville. But if one recording studio is thought of as being part of the scene at the time, it would be Bushflow Studios, located in the home of Tin Huey bass player Marc Price. The studio recorded Tin Huey, of course, but also the Bizarros, the Waitresses, the Rubber City Rebels and a number of other bands that make up Akron's story at the time.

It wasn't the only studio in Akron at the time, though. It wasn't even the only one that the bands just mentioned used when they wanted to record. Krieger was used by at least the Rebels and Tin Huey. Rick Dailey's studio was the home to many of Liam Sternberg's projects and was certainly important in its own right. But Bushflow was the one owned by artists and developed a relationship with another important part of the "Akron Sound" story, Clone Records.

Bushflow Studios started when Price and his brother, Steve, who also played bass in Akron bands, purchased a Teac 4 Track 3340s. "We just had that set up in Marc's basement with some mics," according to fellow Huey Harvey Gold. Things changed a bit when Marc Price purchased an Otari 8 Track, which was a pro machine and really a step above what most people were using to record at that point. Price actually put that piece of equipment in his living room.

"Marc had a big house on Oakdale," said Huey member Chris Butler, who also used Bushflow to record another one of his groups, the Waitresses. Butler remembered people living upstairs and in other rooms, but mostly the house had a big basement. "It sounded good down there," he said. "But the mics were terrible, but I didn't know they were terrible." They were using Electro-Voice RE-10 and RE-20 that Gold purchased with his discount at Audio Warehouse, where he worked at the time. "They were a step up from other mics, but they were thin and flat sounding," said Gold.

Price also picked up a Tapco Mixing Console for the studio. "It was low end but pretty much bullet proof," according to Butler. "It wasn't known for its sound quality, but for its reliability and price." Butler was one of many who lived at the Price house/Bushflow Studios during those years.

Price set his equipment up in his living room, which had a floor covered in blue shag carpeting, according to Butler, and put the studio and any musicians who showed in the basement. How the talk back (communication

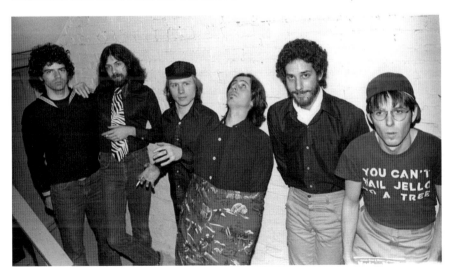

Tin Huey standing in the stairwell between the upstairs boards and the downstairs recording studio. *Courtesy of Harvey Gold.*

between Price at his equipment and the musicians in the basement) occurred was a bit unclear. Gold and Butler remembered there being some kind of talk back, although it might have just been headphones. But then they also remember yelling up the stairs. Whatever the setup, communication wasn't always the best between the musicians and those running the actual recording session.

The Price brothers also bought a number of other items and often tore them apart and rebuilt them for their own use. Gold laughingly recalled some of the playback towers they built looking really impressive while sounding terrible.

The Rubber City Rebels felt there was quite a bit of problem communicating with Price and his colleagues when they recorded their half of the split album *From Akron*. Donny Damage remembered being able to hear Price talking about the problems they were having with their equipment, but neither group was able to talk to the other. That led to the infamous incident where Damage, bassist for the Rebels, became so frustrated with what he saw as the dampening of his group's energy that he urinated into a drain hole in the basement recording studio as a protest of some sort. The longer version of the story has Damage, who was part of the hard-drinking punk crowd, annoyed by the much more mellow crew at the studio, who smoked a whole lot of pot compared to the Rebels' alcohol consumption. The two cultures didn't quite mix. Regardless of Damage's reason, Price kicked them out of the studio, and they had to finish that project somewhere else.

Nick Nicholis of the Bizarros remembered Bushflow as "knowing what they were doing" and trusted the studio to give him a good finished product for his Clone Records label. Regardless of the Rebels' experience, the vast majority of musicians would side with Nicholis and were glad to have access to Price and Bushflow.

Another important member at Bushflow was John Mondl, who was a cousin of Tin Huey drummer Stuart Austin but also someone who had worked at a few different studios before working with Tin Huey. Mondl, who was Tin Huey's sound mixer (someone who takes all the individual sound sources and makes sure they wind up as one clear listenable output), lived upstairs at the house and was the principal engineer there along with Marc Price.

"Their plan was to definitely set up a recording studio in Akron. Marc loved that stuff," said Gold. And while Tin Huey certainly used the studio for their own devices constantly during those years, and a lot of those efforts showed up years later on Tin Huey's 2009 album *Before Obscurity: The Bushflow*

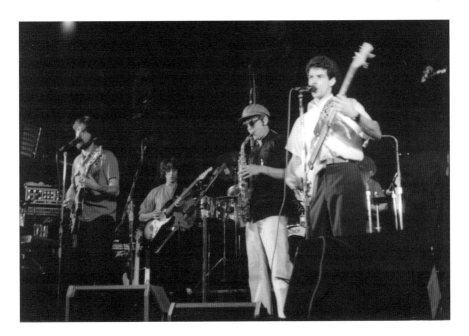

Mark Price (*right*), playing bass for Tin Huey, ran and owned Bushflow Studios. *Courtesy of James Carney.*

Tapes, several other performers did as well. Dave Thomas (Rocket from the Tombs and Pere Ubu) recorded there, and for a while it was the "house studio for Clone Records," according to Gold.

When Warner Bros. paid Tin Huey not to record a second album, even though the first was quite good, most of the band left Akron, landing in New York City and Woodstock, New York. Price stayed in Akron and tried to make a go at Bushflow being a full-fledged recording studio. Unfortunately, interest in bands from Akron had greatly diminished by that point, and the product just wasn't there to make a go of it.

According to Gold, Marc was a spec freak, meaning he didn't always buy equipment based on how it sounded or produced but based on how cool the specs of the machine were; somehow, because of this, he also wound up collecting video gear. His wife, Becky, had come from a horse background, and Price found himself doing videos involving horse shows or horses in general. Somehow the studio recording bands from Akron evolved into a video studio specializing in films concerning horses. The couple eventually left town for San Francisco and continued being a video studio.

Price died in 2008 after a prolonged battle with cancer, but his contribution to the "Akron Sound" can't be overstated. "It was great having that studio,"

One of the four full albums released by Clone Records, *Bowling Balls from Hell. Courtesy of the "Akron Sound" Museum.*

said Gold. "We came from a generation where when we started off we had a cassette deck with some version of mic inputs we were rockin, so this was a luxury."

Butler remembered it all being thrown together and homemade but also thought of it as a luxury. The many, many recordings Tin Huey did at Bushflow were really meant to be demos, recordings to give to record companies so the band could get signed and get into a real 24-track recording studio. Butler will tell you, though, that the demos fall under the idea of "first time right" because of the excitement of the idea finally getting recorded. And they really sound better than the later attempts at a studio a major label would send them to. He hears an energy in those demos that was gone by the time they got in a formal, professional studio. Bushflow's recording was reasonably hi-fi, in his opinion, even though he will also tell you that the mixing board was unlike anything you'd call a professional mixing board. He thinks now that it was perhaps a PA mixing board, a real thrown-together bunch of equipment. "It was DIY, for sure, but we were lucky to have it." That's how Butler, and so many other Akron musicians, will always remember Bushflow Studios.

CLONE RECORDS

While "Akron Sound" bands were released on numerous and better-known labels—including Stiff Records, Warner Bros., Mercury's Blank label and Capital—it is Nick Nicholis of the Bizarros' Clone Records, perhaps along with the English Stiff label, that most fans identify with the era and the bands in town when they reach for an album to put on the turntable.

Nicholis never meant to be a label owner. He had read in a number of magazines how some bands the Bizarros were fans of, such as Pere Ubu and Television, were releasing their own material. He decided that they could do

the same for their band. So, he only originally saw the label as a showcase for the Bizarros, hoping to enhance their chances of getting a major record deal—which they eventually did with Mercury Records' Blank label, though it was short-lived. The Bizarros had their first release on Gorilla Records in 1976 with the *Lady Doubonette* EP, which was subsequently rereleased on Clone Records in 1978.

Nicholis told me that he really never had any plans past the first EP the Bizarros put out. And it wasn't until after the second or third release that he really started thinking seriously about having a record label. As for being a producer, Nicholis will tell you that this is a role he filled in name only. While he is listed as the producer on a few albums, specifically by Unit 5 and John Rader, he really just put up the money more than anything else. He did admit to making sure that things ran smoothly, though, and that everything was done right. But he calls himself a hands-off owner.

But Nicholis won't take any credit for the product, telling me that the guys at Bushflow Studios, which was owned by Marc Price of Tin Huey, knew what they were doing and he trusted them to put out a good product. He just put up money and got a finished product. On the other hand, Tracey Thomas of Unit 5 told me that Nicholis did an amazing job producing their record, so he probably did a bit more than just pay the bills as he likes to claim.

Clone Records owner Nick Nicholis. *Courtesy of the Bizarros.*

Clone Records really put itself on the map when Nicholis asked the Rubber City Rebels if they were interested in releasing a split album with his band. Buzz Clic of the Rebels remembered Nicholis coming into the Crypt, run by the Rebels and a home base for both bands, and asking him if he'd be interested in the idea. Clic was certainly interested in the idea of having an album out and thought it was incredible that they wouldn't have to pay for it. After the album was finished, Nicholis sent the completed split album, *From Akron*, to Robert Christgau of the *Village Voice*, who gave it a very good review.

Nicholis was still a novice at owning and distributing a label. Luckily, he had befriended the band Pere Ubu, who offered advice based on having started their own

label to release their work. Pere Ubu had really only been around a year less than the Bizarros but had already done New York City shows and had started their own label in Hearthan. Nicholis said that Dave Thomas and Peter Laughner of Pere Ubu gave him twenty to thirty names of people he needed to contact and told him who he needed to send his album to if he wanted to get it played on the radio at all. So, with a list of college radio stations, fanzines and writers, Nicholis went to work. He sent his releases to important writers such as Christgau and Greg Shaw, the editor and publisher of *Bomp!* That magazine was a fanzine out of Los Angeles that later also became a label. After being mentioned and reviewed in the *Village Voice* in New York and *Bomp!* in Los Angeles, the label found itself filling orders from around the globe.

It wasn't all work on the national and international level, though. Nicholis talked of how he would take his releases to all the record stores in Akron, Kent and Cleveland and talk to every single record store in Northeast Ohio about carrying Clone Records releases. The overall campaign, both locally and contacting the right people around the country, was hard work and time consuming for Nicholis.

During the next four years, Clone Records released albums by Tin Huey, the Waitresses, Unit 5, Teacher's Pet, Human Switchboard, John Rader and others. It probably made the entire process easier that another band in the scene had started its own studio (Tin Huey's Bushflow), as the two companies collaborated many times over those years. There were also two compilations of Akron bands, called *Bowling Balls from Hell* and *Bowling Balls from Hell II*, released in 1980 and 1981. There were four albums and twelve singles total during the label's four-year run, and a few of the bands that Clone Records released moved on to major record deals, albeit short-lived ones, such as with the Bizarros.

Nicholis closed down the label right around the time he left the Bizarros to take the kind of job and start the kind of career that someone can support and raise a family on.

Albums
- The Bizarros/Rubber City Rebels: *From Akron* (CL-001, 1977)
- *Bowling Balls from Hell*, compilation (CL-011, 1980)
- *Bowling Balls from Hell II*, compilation (CL-013, 1981)
- Unit 5: *Scared of the Dark* (CL-014, 1981)

SINGLES

- The Bizarros: *Lady Doubonette* EP (CL-000, 1978)—originally released on Gorilla Records
- *Tin Huey* EP (CL-002, 1977)
- Bizarros: *Laser Boys* (CL-003, 1978)
- Tin Huey: *Breakfast with the Hueys* (CL-004, 1978)
- Harvey Gold: *Experiments* (CL-005, 1978)
- The Waitresses: *In "Short Stack"* (CL-006, 1978)
- The Human Switchboard: *I Gotta Know/No!* (CL-007, 1978)
- Teacher's Pet: *Hooked on You* (CL-008, 1978)—also released on red vinyl with a red-tinted pic sleeve
- John Rader: *One Step at a Time* (CL-009, 1979)
- Tin Huey: *English Kids* (CL-010, 1980)
- The Housekeepers: *I Gotta Know* (CS-13, 1981)
- The Gray Bunnies: *He Hit Me (And It Felt Like a Kiss)/Cigarette* (CSX-015, 1981)—12" single

The unexpected second life of the label occurred when Nicholis, seeking to get rid of a back stock of albums and singles he had stored in his mother's basement, took them into Square Records in Akron's Highland Square neighborhood and made a deal with the business to sell off the old Clone Record releases. I'm not sure if Square Records or Nicholis really thought that record buyers outside the Northeast Ohio area would be interested,

One of the twelve singles released by Clone Records, Harvey Gold's *Experiments. Courtesy of the "Akron Sound" Museum.*

but they were. A record buyer who had only recently moved to the region from Chicago let his friend at Permanent Records know about what Square had in its bins. The well-established store, which has locations in Chicago and Los Angeles, called Square Records and started putting in orders. It became evident pretty quickly that the number it was ordering was better filled by Nicholis himself as opposed to using Square Records as the middle man, and it directed the Chicago store to the label owner. So, some thirty-plus years

after their original releases, the albums and singles found themselves sitting in a few record stores and moving quickly.

The Bizarros released an album in 2003 after being on somewhat of a hiatus for years and have another one coming out soon. For nostalgia's sake, at least according to Nicholis, they are listed as being released on Clone Records. But it's the same label in name only. It just seems right that a Bizarro album should be released on the Clone Records label. For four years and sixteen releases, Akron had its own label dedicated to capturing the "Akron Sound."

NOT QUITE THE END

AFTER THE SOUND

By the late 1980s or perhaps the early 1990s, the music that had been referred to as the "Akron Sound" had more or less quieted down if not completely vanished, although it was certainly not forgotten, even now a few decades later.

Devo was still releasing albums now and again and is as popular as well, with their third-highest-charting album having come out in 2010. Chi-Pig's *Miami* album, which had sat on the shelf for years, finally found itself released in 2004, by which time Chi-Pig's members had gone on to be lawyers and college professors. The Rubber City Rebels were going on incredibly successful tours throughout Europe and Japan at that same time.

Tin Huey released a few albums from the vaults, while some of them found themselves in New York City involved in television production. As late as 2015, the label Soul Jazz released *Punk 45: Burn, Rubber City, Burn—Akron, Ohio, Punk and the Decline of the Mid-West 1975–80*. Some of the local PBS stations have produced two documentaries on the era.

So, even if there isn't quite an "Akron Sound" today, it still remains on more than a few people's radars. *It's Everything and Then It's Gone* in 2003 and *If You're Not Dead, Play* were both films written and directed by Phil Hoffman and cover the first and second waves of the Akron music scene.

Many of the musicians who participated in the era still play around town, not as oldies acts in any way but rather putting on vibrant, exciting shows. I've seen several of them in just the previous few weeks.

Harvey Gold (Tin Huey), Chris Butler (the Numbers Band/Tin Huey/ the Waitresses), Bob Ethington (Unit 5/Tin Huey) and Deborah Smith (Poor Girl/Chi-Pig) played together in Half Cleveland for some time before Smith retired. The trio has continued with some younger musicians, including the son of original Tin Huey sax player Lochi Macintosh. Butler's current solo work is as good as anything he did that charted in the 1980s. The Numbers Band still play around the area and draw fans from all ages. The Bizarros put on killer shows when the spirit takes them. I was at a CD release party for Robert Ethington (Unit 5/Tin Huey) in the fall of 2016 where Ralph Carney came in from the West Coast to play. The Buzz Clic Adventure plays regularly on the West Coast, and Tracey Thomas (Unit 5) can be seen on a regular basis in the area. Some of the participants of the era have even formed new bands, such as the Bad Dudes or the Crowders. They are still drawing satisfied and enthusiastic crowds.

The list could go on and on, but it's safe to say that the musicians from the era still are putting out vibrant music on a regular basis. People that creative don't become oldies acts.

New sounds and artists started appearing in the late 1980s that, while certainly Akron-centric, were a bit different than what the region had become used to. And while these new artists weren't labeled as part of a similar movement, their music reflected the Akron they came from. And they often found themselves influenced by the bands that came before them.

In the late 1980s, a sixteen-year-old bass player named Joseph Arthur found himself in a straight-ahead blues band called Frankie Starr and the Chill Factor. At the time, the teenage Firestone High School student wanted to be the new Jaco Pastorious, the next great bass virtuoso. Fortunately for us, Arthur, a few years after graduation, moved to Atlanta with Mike Hammer of the Rubber City Rebels and Hammer Damage with the group Ten Zen Men and started applying himself seriously as a songwriter. In 1996, he released his first EP, *Cut and Blind*, which found appreciative ears in Peter Gabriel and Lou Reed. Arthur has had a successful career as both a musician and artist. He earned a Grammy nomination in 2000 for best recording package, an honor given to the art director of the interior and exterior of the released album's packaging. And Joseph Arthur the artist likes to serve as the art director for Joseph Arthur the musician. I've had a few of his fellow musicians tell me that

Joseph Arthur at Musica in 2008.
Courtesy of Shan Spyker/Sisters Dissonance.

they knew he'd be a star while still a teenager. As Tracey Thomas told me, "He was just wickedly talented."

Part of what makes Arthur still part of the Akron landscape is that he still spends a fair amount of time in town and plays a Thanksgiving Eve show here every year, usually at the Tangier. It's an annual event that marks the start of the holiday season. And just as important, while the Chill Factor broke up in 1995, Frankie Starr still performs around town with his current band.

Around the same time as Arthur was working toward becoming a bass virtuoso, another young man was starting his career as a heavy metal vocalist and front man that would take him around the world representing Akron many, many times. Tim "Ripper" Owens started performing around the same time as Arthur, handling the vocals for the metal band Damage Inc. in 1986. Owens also fronted Brainicide for a few years, breaking up not long after recording the demo tape *Damage Daze* in 1990. I met Owens briefly right around this time, as a friend and co-worker of mine played bass in Winter's Bane, the band Owens joined after Brainicide. My friend had left the band by the time Owens and Winter's Bane recorded *Heart of a Killer* in 1993. But the few times I met the talented and driven singer caused me to laugh out loud when I saw the film *Rock Star*, supposedly based on his real-life story.

To allow them to easier work in their original set lists to bar crowds, Winter's Bane formed the Judas Priest cover band Blue Steel. They would open the shows as Winter's Bane, playing their originals, and then take the stage as Blue Steel and play very effective Judas Priest covers for the crowds. And while Winter's Bane was a quartet, their sound man would join the band on stage to fill out the Blue Steel experience. In the interests of journalistic fairness, it should be noted that on the album Winter's Bane released in 1991 before Owens joined the band I am thanked in the credits as the meanest man alive—a title and description I neither accept nor deny.

Everyone thinks that they know the story of how Owens was plucked from obscurity and, just as quickly, split from the band. The truth is that Rob

Tim "Ripper" Owens. *Courtesy of Tim "Ripper" Owens.*

Halford had been gone for a few years and picking Owens was no kneejerk reaction by the band. He stayed with them for four albums and seven years, receiving a Grammy nomination for best metal performance for "Bullet Train" in 1999. The movie based on his life was a joke.

He had also recorded his first album as the lead singer of Iced Earth before the split with Judas Priest and maintains a solid friendship with the band members to this day. Owens went on to record a number of albums with Iced Earth. He followed that up with another few albums fronting Yngwie Malmsteen's Rising Force and now either performs with Charred Walls of the Damned or as a solo artist.

But like so many Akron artists, the Kenmore High School graduate still maintains roots in the community. Owens first opened Ripper Owens Tap House in the Firestone neighborhood before opening Ripper's Rock House in his old Kenmore neighborhood. The Rock House was a great venue for live music and was featured on the *Bar Rescue* television show on Spike TV. On the program, the hosts of the show helped Owens transform the Rock House into Tim Owens' Traveler's Tavern. The idea behind the transformation was that Ripper Owens was so identified as a heavy metal icon within the area that people just assumed it was a heavy metal club instead of a great rock club with some amazing wings.

Owens still performs around town on a regular basis, but more often than not, he can be found touring the world with his band, always representing Akron.

Over the past fifteen years, probably no group has meant Akron to those outside the region as much as the Black Keys. Much like Owens, I had a passing nod with the Black Keys as well. Somewhere around 2003, I ventured down to what was then known as the Lime Spider, now known as the Lockview, with a friend to see their friend's band, the Black Keys. A year or two after that, I tracked down a bootleg of a Black Keys show for the same friend after he found himself in Iowa City at the same time as the Keys and Dan Auerbach gave him a shout out from the stage. A few years after that, they began releasing hit albums—and I mean top of the charts.

While a lot of current bands were influenced by the many artists from the "Akron Sound" era, the Black Keys have a very traceable connection. Patrick Carney is the nephew of Tin Huey saxophonist Ralph Carney, who has played with many acts since leaving Akron years ago—most notably as Tom Waits's saxophonist. Ralph Carney played on the Black Keys' 2008 album *Attack & Destroy*, as well as performed on stage with them multiple times during the tour to support the album. He also co-wrote the theme song

The Black Keys at the Lime Spider in 2005. *Courtesy of Brad Lentz.*

with his nephew for the Netflix program *BoJack Horseman* in 2014. And while he was never part of the Akron music scene, Robert Quine was the cousin of Auerbach. Quine, who is best known as a unique-sounding guitarist in the New York scene for years, was an Akron native and is best remembered for his work with Lou Reed.

Dan Auerbach and Pat Carney knew each other from childhood, having both grown up in the Firestone neighborhood. And while they jammed together as early as 1996, it was a few years later that they actually formed a band, and then really only after Auerbach asked Carney's help in recording a demo that Auerbach could shop around.

The Black Keys certainly had the sounds of Akron within their music, recording three of their first five releases in Carney's basement, as they wanted to sound like a band from the Midwest—and very few cities are as Midwest as Akron. Another early album, *Rubber Factory*, was actually recorded on the second floor of the abandoned General Tire rubber plant in Akron.

Carney has kept his foot in Akron, even though, like Auerbach, he moved to Nashville in 2010. Carney has produced albums for the Akron pop band Houseguest, and his band Drummer performed at a benefit show in town dedicated to band friend Dan Van Auken, who died of brain cancer in 2014. Drummer recorded their only album in Akron as well.

The Black Keys' work, as a duo and as solo musicians, resonates with the sound of a Midwest rock band awash in blues and abandoned factories. They perfectly capture Akron.

Another band that has an interesting sound, labeled as either post rock or post metal by those who care to do so, is If These Trees Could Talk. They released an EP in 2006 and have followed up with three albums over the next decade. Not seeing the need for vocals, this band certainly serves as a standard bearer for unique-sounding bands from the region.

Red Sun Rising is the latest Akron band to make some noise on the national level, reaching number one twice and the Top 10 three times on mainstream rock charts with singles from their first album, *Polyester Zeal*. The band's lead guitarist, Ryan Williams, is the nephew of Unit 5 lead singer and solo artist Tracey Thomas. It seems that being an Akron musician is a bit of a legacy. They are yet another band/artist to brush up against me ever so briefly. Very early in their career, somewhere between 2009 and 2011, I attended a show where they were the opening act. The enterprising young band was pressing their own EPs and passing them out at shows. I picked one up, because one never knows, and now the "Akron Sound" Museum owns a CD from the area's

If These Trees Could Talk hanging out in an Akron parking deck. *Courtesy of If These Trees Could Talk and Sandra Kelly at NEMeadows Studio.*

newest hitmakers that isn't listed on any discography. They also fall neatly into the genre of Akron bands by not falling into *any* other genre. The band refers to themselves as WeAreThread Music, as there are too many different threads of influence on their music to successfully define themselves as one genre. Sounds like the perfect description of an Akron band.

The Tobias brothers aren't as well known as some of these other performers, but if you mention them as longtime participants in the Guided by Voices universe, everyone is aware of them. Tim Tobias is the older of the brothers and has been a member of Guided by Voices. Younger brother Todd has been a producer on a lot of Guided by Voices and related side projects of that entity over the years. They, along with GBV front man Robert Pollard, have also recorded over the years as the Circus Devils. They both have extensive discographies. More importantly, Todd remembered being knocked about by Devo's *Shout* and how it formed his musical direction. He and a friend of his were so taken by Devo that they went down to visit General Boy in the mid-1980s. Current musicians' connection with the "Akron Sound" are pretty easy to track. In conversations with Tobias, he spoke in length about how Devo, and specifically drummer Alan Meyers, inspired his own musical efforts.

There are still a lot of local acts around Akron that haven't broken out yet but have a huge fanbase that thinks it's just a matter of time. Ryan Humbert has been entertaining the area for well over a decade with his Americana-tinged musical stylings. He has also formed a musical partnership of sort by often working with Tracey Thomas, formerly of Unit 5 but a solo performer for the past thirty years.

Wesley Bright makes you feel like you are watching an Atlantic Records show from 1967. But he isn't just an homage to groups from a different time; he's an honest-to-goodness honey-voiced R&B star of the classic mold. During 2016's First Night, the New Year's Eve celebration held in downtown Akron, Bright headlined the evening with a show at the Akron Civic Theater. Both Wesley Bright and the Ohio Weather Band played the Music Box Stage at Brite Winter, one of the premier music festivals in Northeast Ohio, in 2017. The Ohio Weather Band has released two albums and are just an incredibly fun and energetic live act. They opened for Bon Jovi during that band's Cleveland stop in March 2017. While it was their first time performing in front of an arena-sized crowd, it certainly won't be their last. They scream future success.

While those iconic clubs such as JB's, the Crypt and the Bank no longer exist, there are plenty of places to catch live music still in Akron—quite fortunate for the acts mentioned throughout and those who love to hear and see them. There have been a few attempts to "reopen" JB's and the Bank, but as they were really only pale copies of the legendary spots, the clubs never really succeeded. In large part, this is because clubgoers today have no interest in spending their nights at a place they know isn't going to capture the spirit of the legend their parents, or even grandparents, made. No, they are planning on making their own legends.

These latest incarnations of JB's and the Bank both closed around the last year or two, but a lot of places are still open for live music, some going back into the era of the "Akron Sound." The Akron Civic Theater still is a premier concert venue in town, stretching back to 1929 in downtown Akron. These days, it's more a concert venue for national acts such as Alice Cooper, Hall and Oates, the United States Naval Concert Band and Ballet Excel Ohio than local shows. In 2008, though, the Black Keys, Devo and Chrissie Hynde did a benefit show for the Summit County Democratic Party and Barack Obama. The hip-hop community still loves to remember the shows held there where the best of the best would gather to show off their music at the Civic.

Right down the street from the Civic is Lock 3 and Lock 4. While Lock 3 is a great outdoor amphitheater for the summer months, its sister location,

Lock 4, remembers Howard Street with its mix of jazz, blues and gospel. Blu Jazz in the Historic Arts District also puts on some great jazz shows. Right across the alley is Musica, where the stage hosts local acts pretty regularly. The "Akron Sound" Museum had its first event and fundraiser there in January 2016.

Jilly's Music Room is the club that features some acts from the classic era performing there on a regular enough basis that fans have taken notice. The Numbers Band, the Bizarros, Half Cleveland and Tracey Thomas of Unit 5 all grace Jilly's stage fairly regularly—as creative, vibrant and as entertaining as they were thirty to forty years ago.

The Vortex gives the stage to a lot of performers that might not have one otherwise. In the fall, it hosted a '90s hip-hop show, bringing back some acts that hadn't performed in the area for a while. The Empire Concert Club is the spot to listen to hard rock and metal since Tin "Ripper" Owens closed his club to concentrate on his musical career, which still takes him around the world.

Every fall, the Highland Square neighborhood hosts PorchRckr, a daylong event where houses throughout a few blocks give up their porches to let countless bands take over their neighborhood and just jam all day. It's an amazing event.

Also in the Highland Square is Annabelle's Lounge, which has been featuring live music for as long as I can remember and still gives its stage up to what Akron has to offer.

In many ways, the last few decades have changed the relationship between Akron and Kent. While always different culturally, there was a bit more of a connection thirty to forty years ago. Not so much today. Kent has some great live music venues too: Stone Tavern at Michel's, the Outpost Concert Club, the Water Street Tavern and, for big shows, the Kent Stage. In 2010, the Kent Stage hosted *Debacle*, which was an amazing evening with so many bands and performers from the era. The place was packed, and everyone remembered the days when it seemed that Akron/ Kent was the center of the musical universe.

Akron may not be a focal point of a certain genre of music like it was during the late 1970s and early 1980s. Seattle had its moment in the sun, as did Austin, Texas. And Akron had its own, but that doesn't mean the music being created there now is any less incredible. A lot of us feel that Akron's best musical days are ahead of it. But those who came before today's musicians need to be remembered and, more importantly, enjoyed. There were some great bands and performers. And we had one hell of a good time.

BIBLIOGRAPHY

Ashley, Jane. Interview with the author, May 23, 2017.

Buckner, Jerry. Interview with the author, January 31, 2017.

Butler, Chris. Interview with the author, February 9, 2017.

———. Interview with the author, May 21, 2017.

Butler, Chris, and Harvey Gold. Interview with the author, May 14, 2017.

Carney, Ralph. Interview with the author, March 9, 2017.

Christgau, Robert. "From Akron." *Village Voice*, 1977.

———. "A Real New Wave Rolls Out of Ohio." *Village Voice*, April 10, 1978.

Clic, Buzz. Interview with the author, March 1, 2017.

Ethington, Bob. Interview with the author, May 17, 2017.

Firestone, Rod. Interview with the author, March 14, 2017.

Gold, Harvey. Interview with the author, February 8, 2017.

Hammer, Mike. Interview with the author, June 7, 2017.

Imij, Jimi. Interview with the author, March 2, 2017.

Kidney, Robert. Interview with the author, June 6, 2017.

Nicholis, Nick. Interview with the author, May 17, 2017.

Nicholis, Nick, Don Parkins and Mike Parkins. Interview with the author, March 23, 2017.

Purkhiser, Mike. Interview with the author, May 30, 2017.

Smith, Debbie. Interview with the author, May 31, 2017.

Thomas, Tracey. Interview with the author, May 1, 2017.

Tobias, Todd. Interview with the author, April 26, 2017.

Zagar, Dave. Interview with the author, May 10, 2017.

————. Interview with the author, May 23, 2017.

ABOUT THE AUTHOR

Calvin Rydbom is the author of three Arcadia books: *Images of Modern America: Akron, Images of America: Cleveland Area Disasters* and *Images of America: Burton, Ohio*. He is the vice-president and archivist of the "Akron Sound" Museum. Calvin is also vice-president of Pursue Posterity, a freelance archiving firm in Northeast Ohio. Calvin has a master's in library sciences from Kent State and a master's in English from the University of Akron. He has published a number of music-related articles and has worked on online projects for the Cleveland Memory Projects on Cain Park, Playhouse Square and Burton, Ohio. Calvin was also elected to the Society of American Archivists steering committee on recorded sound in 2015–16 and was elected to be its website liaison as well as a steering committee member in 2016–17.

Visit us at
www.historypress.net